THE VANCOUVER SKETCHBOOK

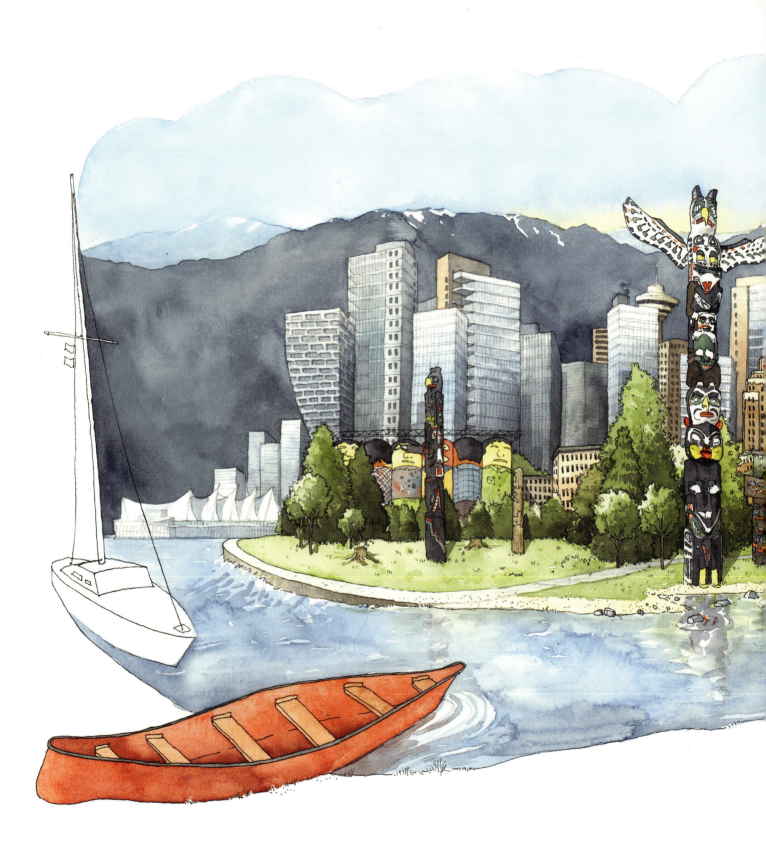

THE VANCOUVER SKETCHBOOK

Lush Landscapes / Vibrant Streetscapes / Soaring Skyline

Written and Illustrated by **T.K. Justin Ng**

whitecap

Text and illustrations Copyright © 2019 by T.K. Justin Ng
Whitecap Books

All rights reserved. No part of this publication may be reproduced, stored in a retrieval system, or transmitted in any form or by any means, electronic, mechanical, photocopying, recording, or otherwise, without the prior written permission of the publisher. For more information contact Whitecap Books, at Suite 209, 314 West Cordova Street, Vancouver, BC, V6B 1E8 Canada. Visit our website at www.whitecap.ca.

The information in this book is true and complete to the best of the author's knowledge. All recommendations are made without guarantee on the part of the author or Whitecap Books Ltd. The author and publisher disclaim any liability in connection with the use of this information.

DESIGN Andrew Bagatella and T.K. Justin Ng
COVER DESIGN T.K. Justin Ng
ILLUSTRATOR T.K. Justin Ng

Library and Archives Canada Cataloguing in Publication

Title. The Vancouver sketchbook : lush landscapes, vibrant streetscapes, soaring skyline / written and illustrated by T.K. Justin Ng.
Names: Ng, T. K. Justin, author, illustrator.
Identifiers: Canadiana 20190109297 | ISBN 9781770503250 (hardcover)
Subjects: LCSH: Ng, T. K. Justin—Travel—British Columbia—Vancouver. | LCSH: Ng, T. K. Justin—Notebooks, sketchbooks, etc. | LCSH: Vancouver (B.C.)—Pictorial works. | LCSH: Vancouver (B.C.)—Description and travel.
Classification: LCC FC3847.3 .N42 2019 | DDC 971.1/33—dc23

We acknowledge the financial support of the Government of Canada through the Canada Book Fund (CBF) for our publishing activities and the Province of British Columbia through the Book Publishing Tax Credit.

Nous reconnaissons l'appui financier du gouvernement du Canada et la province de la Colombie-Britannique par le Book Publishing Tax Credit.

7 6 5 4 3 2 1

To
my grandparents,
my father,
my brother,

and once again,
to my mother.

Photo by Peter Kwak.

"Beauty is truth, truth beauty,"–that is all
Ye know on earth, and all ye need to know.

–"ODE TO A GRECIAN URN," JOHN KEATS, 1819

CONTENTS

MAP LOCATIONS X

INTRODUCTION 1

9 NATURE'S PROPHESY
- North Shore Mountains 10
- Stanley Park 12
- Siwash Park 13
- Museum of Anthropology 16

21 INDUSTRY OF MAN
- Brockton Point 22
- Gastown 27
- Yaletown 39
- Chinatown 44
- Dominion and World Buildings 48
- Hotel Vancouver 51

53 FROM RESOURCES TO REVELRY
- Rowing Club 55
- Seawall 56
- Lost Lagoon 58
- Marine Building 59
- The VanDusen, Bloedel and The Beaty 62
- Twin Viaducts 72

75 THE ROAD LESS TRAVELLED
- Robson Square 84
- English Bay 88
- Granville Island 96

105 PICTURE PERFECT
- Canada Place 110
- Skytrain 112
- Science World 113
- Chinese Garden 116
- David Lam Park 121
- Charleson Park 126
- My Room 130

133 OUT OF FRAME
- Steam Clock 135
- Totem Poles 139
- Shaughnessy Heights 143
- Hastings and Main 144

149 MORE THAN A CITY OF GLASS

NOTES 154

ACKNOWLEDGEMENTS 155

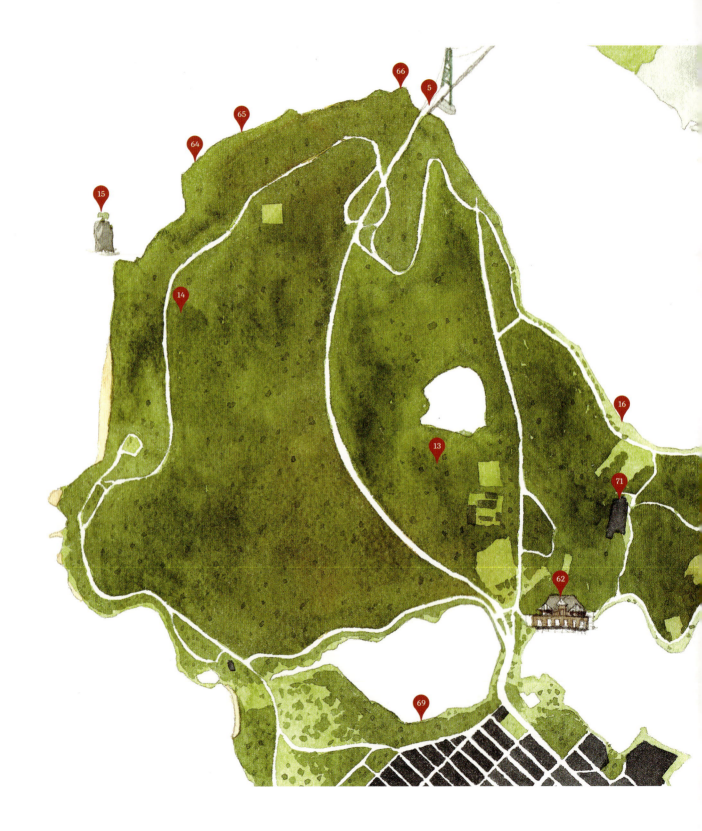

XIII | MAPS

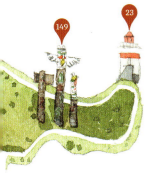

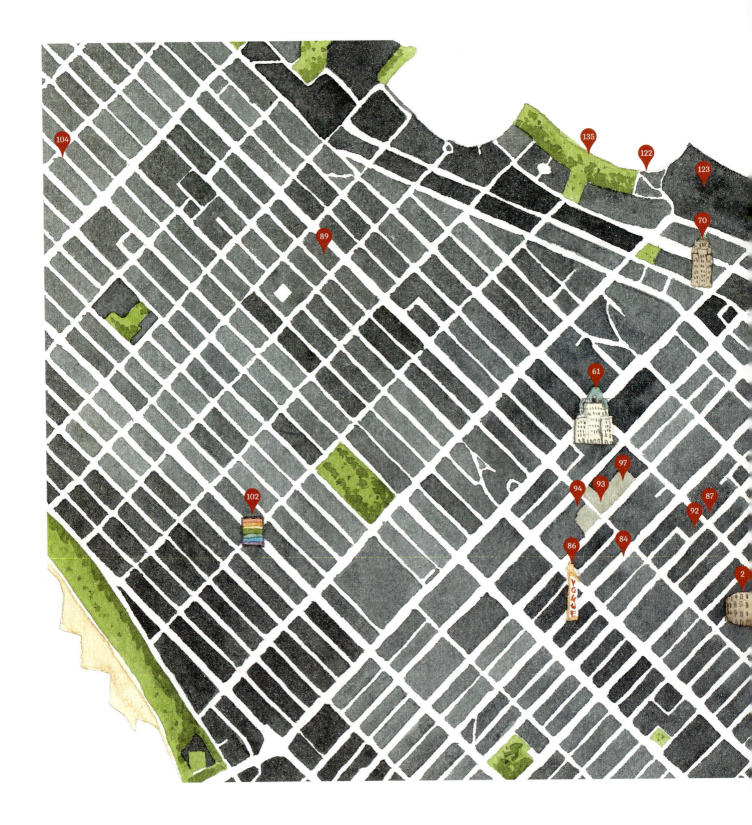

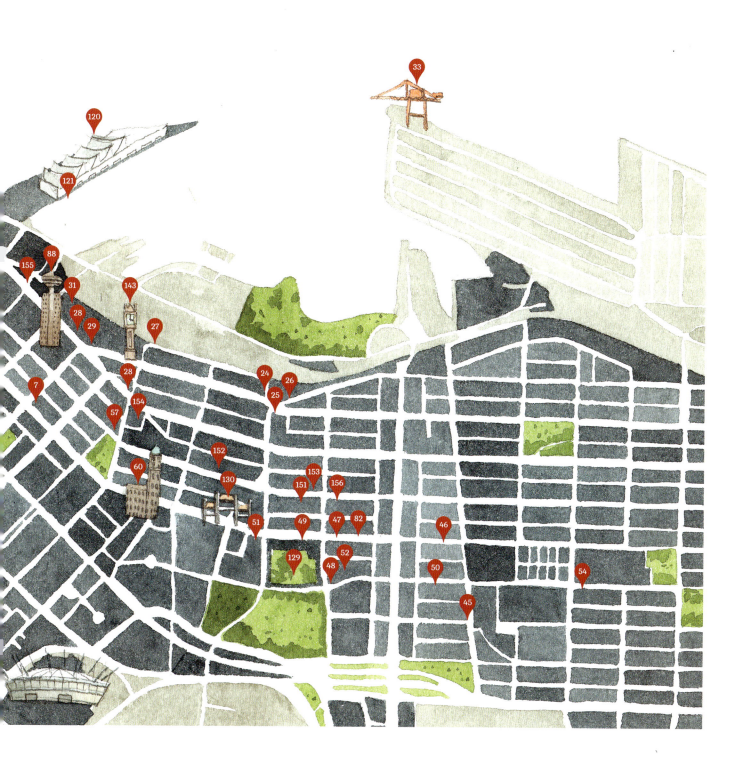

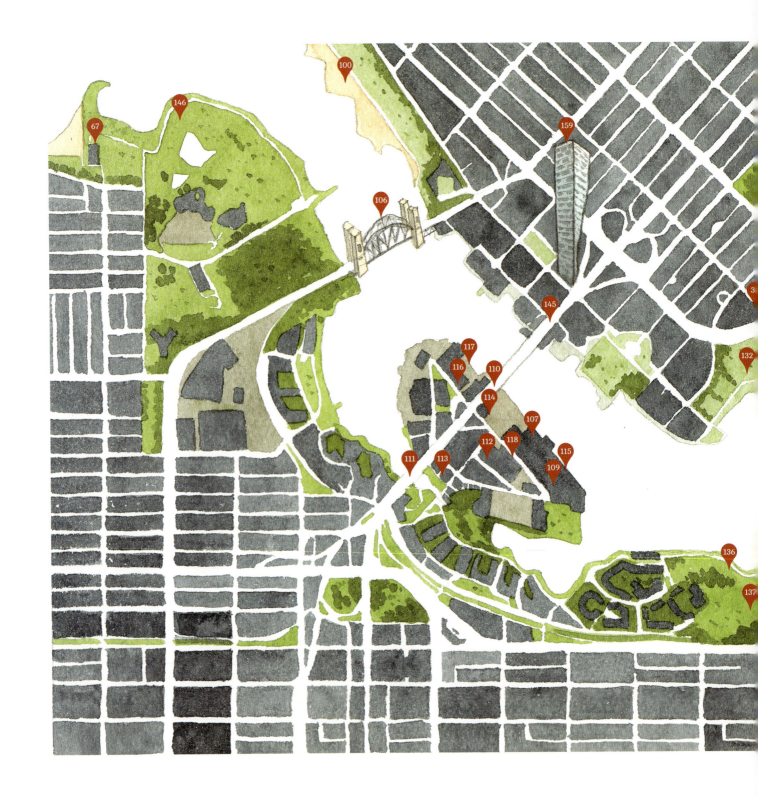

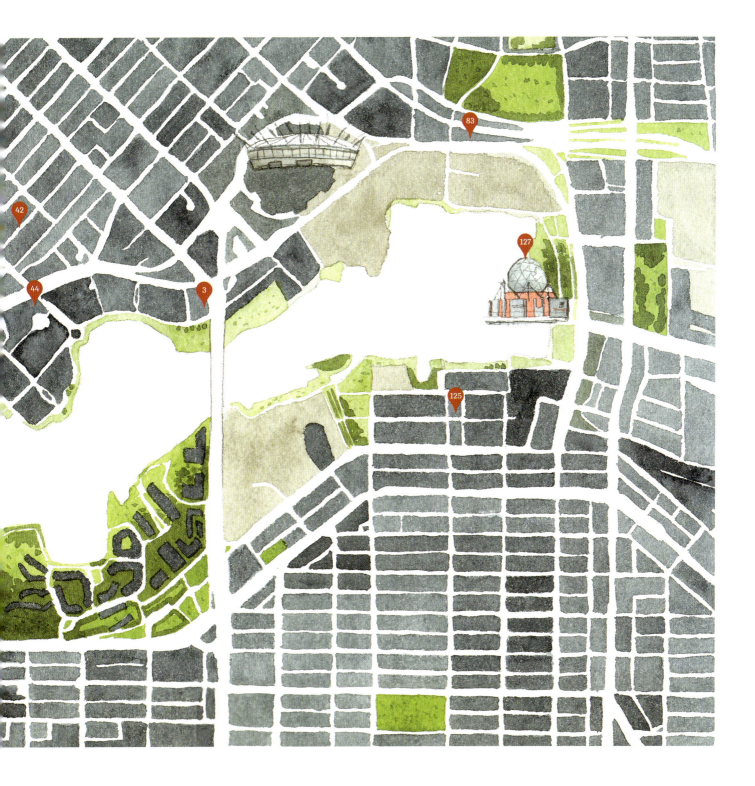

MAP LOCATION LIST (Map numbers refer to illustration numbers)

2. Vancouver Public Library

3. North side of Cambie Street Bridge

5. Lions Gate Bridge

7. MacLeod's Books

9. Lynn Canyon Park

10. Lynn Canyon Park Suspension Bridge

12. Grouse Mountain

13. Stanley Park Forest

14. Hollow Tree at Stanley Park

15. Siwash Rock

16. Canoes docked on Stanley Park

22. Britannia Mine Museum

23. Brockton Point Lighthouse

24. A bar at the intersection of Water and Carrall streets

25. Intersection of Water and Carrall streets

26. The bar in place of where Globe Saloon once prospered

27. A backstreet in Gastown

28. One of many "flatiron" buildings in Gastown

29. The Landing building

30. Waterfront Station's main concourse

31. Waterfront Station

33. Gantries at the Port of Vancouver

37. Vancouver's City Hall

38. End of Hamilton Street in Yaletown

41. The former warehouses of Yaletown

42. Elevated loading docks turned patio in Yaletown

43. A bar in Yaletown

44. Engine No. 374 at the Yaletown Roundhouse pavilion

45. A market in Chinatown

46. Dollar Meat Store in Chinatown

47. Colourful heritage buildings along East Pender Street in Chinatown

48. Chinatown Memorial Monument

49. A bookstore in Chinatown

50. Keefer Rooms building in Chinatown

51. Sam Kee Building, "shallowest commercial building in the world", on Pender Street

52. A vacant plot of land in Chinatown

53. A back street in Strathcona

54. A Buddhist temple in Strathcona

57. Dominion Building

60. The World Building (Sun Tower)

61. Hotel Vancouver

62. Vancouver Rowing Club

64. The Seawall

65. The Seawall

66. Prospect Point

67. Maritime Museum

69. Canada Geese beside Lost Lagoon

70. Marine Building

82. The Man Society building in Chinatown

83. West Georgia and Dunsmuir viaducts

84. The Orpheum on Granville Street

86. The Vogue Theatre on Granville Street

87. Hudson's Bay building

88. Harbour Centre

92. Scotia Tower

93. Robson Square

94. Elevated walkway beside Robson Square

97. Vancouver Art Gallery

100. Sunset Beach

102. A street crossing in Davie Village—often referred to as Gay Village—is painted in the colours of the pride flag.

104. Restaurant on Denman Street

106. Burrard Bridge

107. Granville Island from North False Creek

109. A yellow crane on Granville Island

110. A decommissioned fishing boat underneath the Granville Bridge

111. Granville Island neon sign

112. Old warehouses on Granville Island

113. The Kids' Market on Granville Island

114. Granville Island shops

115. Sea Village on the coast of Granville Island

116. Granville Island Public Market

117. Steps outside Granville Island Public Market

118. Building that once housed the Emily Carr Art and Design University

119. Deadman's Island

121. Cruise ship beside Canada Place

122. Seaplanes docked beside the Vancouver Convention Centre

123. The Vancouver Convention Centre

125. The red salt house in Olympic Village

127. Science World

129. Dr. Sun Yat-Sen Classical Chinese Garden

130. Chinatown Millennium Gate

132. Condominiums beside David Lam Park

135. Condominiums along Coal Harbour

136. Charleson Park

137. Dog park in Charleson Park

143. Steam Clock in Gastown

145. The underside of Granville Bridge

146. Gate to the Northwest Passage in Vanier Park

149. Brockton Point Totem Poles

151. Flea Market on East Hastings Street

152. Save-On Meats

153. East Hastings Street

154. Woodward's Development

156. Balmoral Hotel

159. Vancouver House

1. Two water brushes, a fountain pen, a mechanical pencil and a box of watercolours—the tools I used to draw Vancouver. Not shown is my portable stool.

INTRODUCTION

SITUATED WEST OF the Rocky Mountains, where creeks and inlets of the Pacific Ocean penetrate deep inland, Vancouver is a temperate maritime city poised between snow-capped mountains and the speckled sea. Not only is the natural landscape beautiful and nature's resources bountiful, Vancouver is also a city rich in culture. Ever since the First Nations arrived here more than ten thousand years ago, this land has welcomed people from all over the world and transformed itself into an international metropolis. Today, more than 600,000 people call Vancouver home and the city's success is attributed not to a singular culture but to a multiplicity of them. As such, Vancouver is a collage of cultures and identities that emerged out of centuries of exchanges between different people against a dynamic natural landscape.

Like many Vancouverites, I was raised in Hong Kong, a place on the other side of the planet, yet intertwined with the West Coast after centuries of trading. My grandparents moved here several decades ago and I first visited Vancouver at the turn of the millennium. Away from the dense and tropical Hong Kong metropolis, Vancouver's temperate climate and park-filled neighbourhoods made me fall in love with this coastal jewel. From then on, every couple of years, I would fly across the Pacific to spend a week or two in Vancouver. It was not long before I wanted to stay.

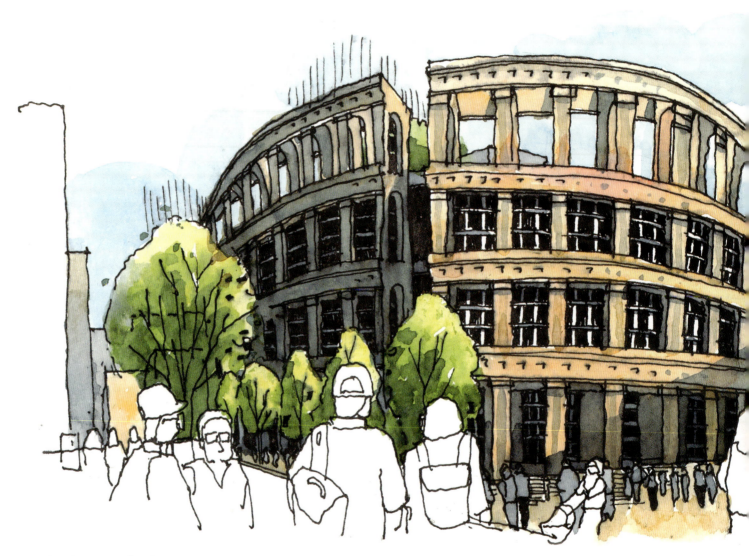

2. The first drawing I made in Vancouver is of the Vancouver Public Library designed by Moshie Safdie.

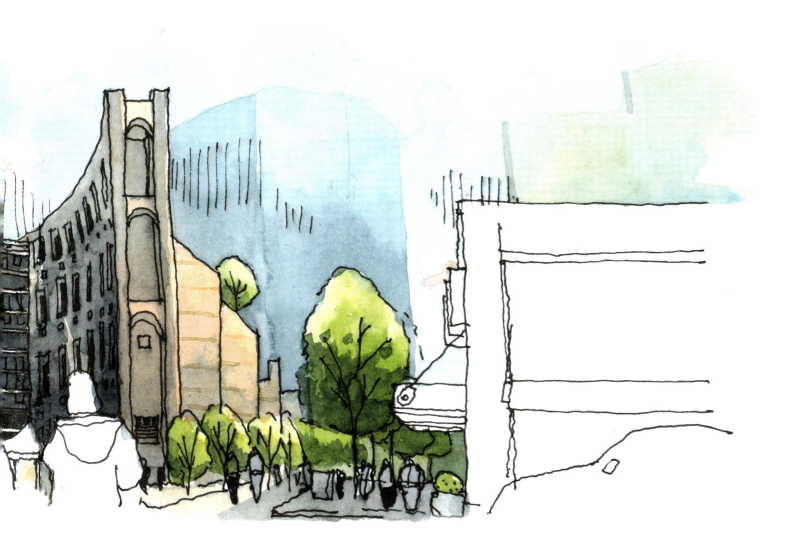

I still haven't achieved my childhood dream of living here permanently, but recently had the opportunity to spend several straight months in Vancouver. At second blush I was immediately drawn to the city's streetscapes and landscapes. In many ways, Vancouver is a contemporary picturesque city, a place where unexpected beauty lies around every corner. Walking through downtown, I could not help but notice that the various city scenes always effortlessly arranged themselves into artistic compositions, yearning to be captured. Even the most seemingly mundane streets provide a moment of surprise, when snow-capped mountains emerge as backdrops to back alleyways. Perhaps this is why the city is filled with

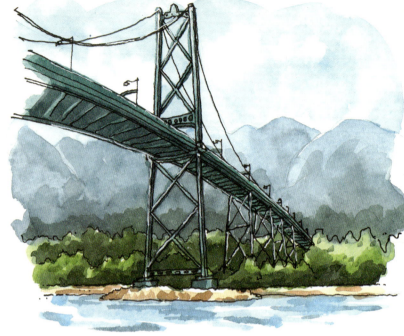

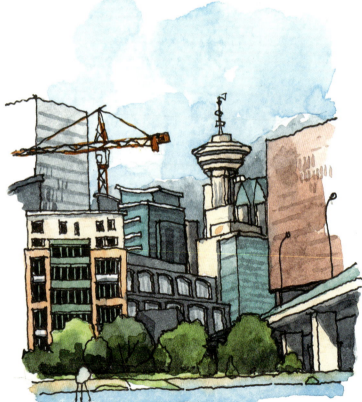

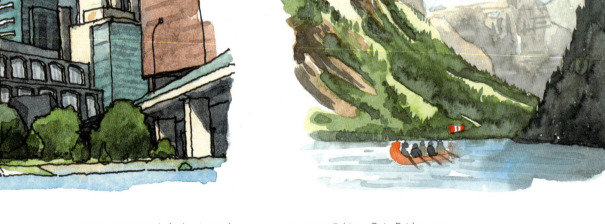

BOTTOM LEFT 3. New construction in North False Creek at the foot of Granville Bridge.

BOTTOM RIGHT 4. Lake Louise and the sublime landscapes of the Rocky Mountains.

TOP RIGHT 5. Lions Gate Bridge spans Burrard Inlet and ties Vancouver to the north shore mountains.

photographers, and why filmmakers from all over the world have transformed it into "Hollywood North," the photogenic city so often cast in movies.

While some choose photography or videography as their way of capturing experiences, sketching is the means by which I codify—mine. From the garden city of Singapore to the winter wonderland of Helsinki, and from my childhood home of Hong Kong to my current home in Toronto, I have made over a thousand drawings of various cities around the globe.

Not only is each drawing an opportunity to capture memories of a place, each is also a lesson on architecture and urbanism. At a time when screens are becoming the interface for much of life, being on-location exposes me to the nuances of light, sound and smell—qualities of architecture that cannot be experienced digitally. In the process of recreating what lay before my eyes on paper, I became intimately acquainted with the subject before me. Sketching en plein air, or outdoors as I have done here, relies on a human perspective, filled with emotions and empathy. It is perhaps a more human way of understanding our cities in this ever-digitizing world.

Vancouver's picturesque qualities made me draw more rigorously than I ever have, spring-boarding me into an exploration of Vancouver's urbanism and its visual identity. After filling up many sketchbooks with drawings from Vancouver, I decided to share my observations with the public in the form of a book. From Rugendas's *Voyage Pittoresque dans le*

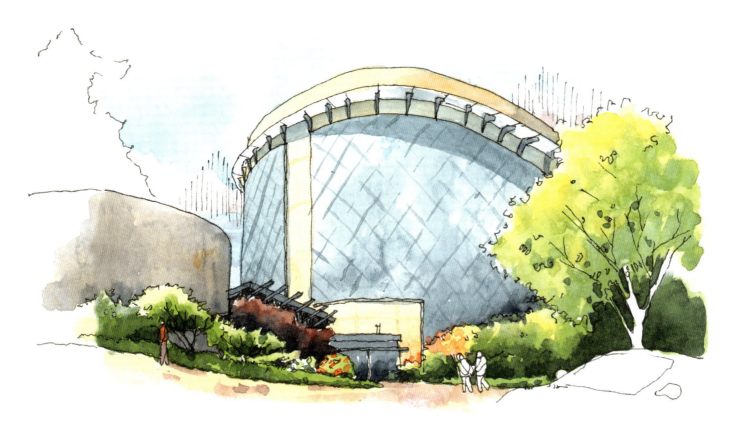

6. Chan Centre for Performing Arts is located on the campus of UBC.

Brésil (Paris, 1827-1835, "Picturesque Voyage in Brazil") to Tenré's *Voyage pittoresque dans les deux Amériques* (Paris, 1836, "Picturesque Voyage in the Two Americas"), picturesque travel books have historically used sketches as a framework in shaping European understandings of the American world. By observing Vancouver through drawing, this book also positions itself as a continuation of the tradition of picturesque travel books.

Rather than pure imagery, this book explores Vancouver's pictorial identity using a selection of personal observations and history. At the same time, this book is by no means a comprehensive sketchbook of Vancouver, but a guide to what most captured my eyes and my heart. Driven by my relationship with Vancouver, this book is also in part an autobiography (albeit an incomplete one), where I provide an honest account of how Vancouver has shaped me. By tying together these drawings and my notes on the city, I hope to share with you how the people of Vancouver—sometimes accidentally but often deliberately—transformed this corner of the planet into a contemporary beauty.

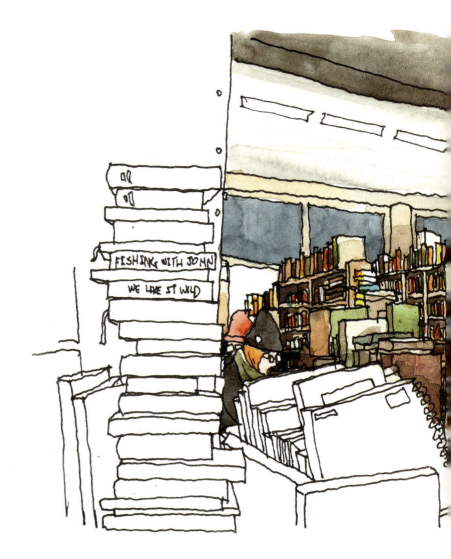

7. MacLeod's Books in Gastown is a cornucopia of knowledge. Having read many of the books in the store, the owner, Don, is a walking encyclopedia.

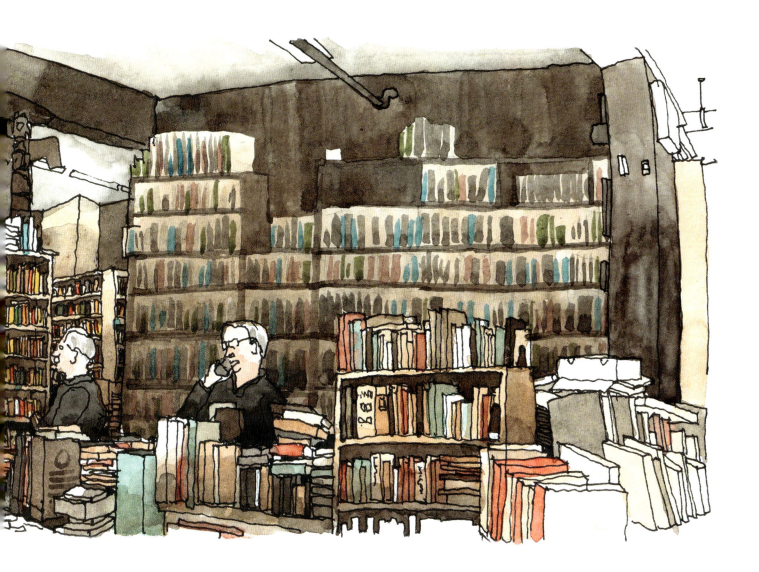

NATURE'S PROPHECY

NORTH SHORE MOUNTAINS

Ever since moving to Vancouver, the North Shore mountains have provided the luring promise of a convenient escape from the city. Following the footsteps of many Vancouverites' weekly exodus to the mountains, I spent several weekends exploring the region's natural beauty.

Among all the mountains near Vancouver, Grouse Mountain stands out. It is a popular destination year-round, with hikers in summer and skiers in winter. Just ten kilometres from Vancouver's city centre, it is the perfect getaway for those urbanites unfamiliar with the wilderness but eager for a taste of the natural. Most visitors take the gondola, but some hike the Grouse Grind, a trail consisting of almost three thousand stairs snaking along a steep serpentine walkway that traverses a sumptuous forest of pine and Douglas fir. After weeks in the bustling metropolis, the crisp sound of dead branches snapping under feet were antidotes to hectic urban life. But the needle-strewn trails are also far from natural; from the pieces of log that make up the stairs to the safety ropes hanging between tree trunks, reassuring signs of humanity are sprinkled everywhere along the path. Even the trail route, though heavily influenced by topography and the position of existing trees, can be considered a deliberate curation of the landscape that is carefully maintained by park authorities.

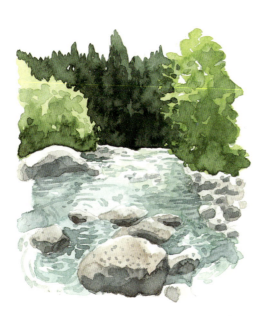

8. The Gondola is the means by which most tourists get to the top of the mountain. Many locals prefer to hike.

BOTTOM LEFT
9. Stream flowing through Lynn Canyon Park in North Vancouver.

BOTTOM RIGHT
10. The Lynn Canyon Suspension Bridge is the most popular destination in at the park.

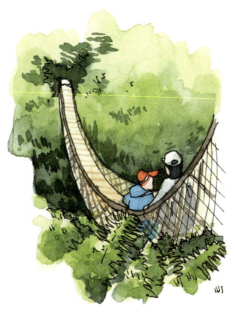

Hiking through these rich forests, it is hard to imagine that for several millennia, Vancouver was trapped beneath a thick sheet of ice. It was only when the last ice age drew to an end ten thousand years ago that a lively ecology began to take hold. Lynn Canyon, today a popular tourist destination, was a crack in the landscape filled with minerals left behind by the glaciers. Not only did these minerals fertilize the soil, Vancouver Island shielded the coast from harsh storms, and the mountains forced winds from the Pacific to soak the earth with plentiful rainfall. Through nature's benevolence, this corner of the planet was gifted with bountiful necessities of life and became a paradise for plants and animals.

11. Mountains washed purple during the sunset in the Rocky Mountains.

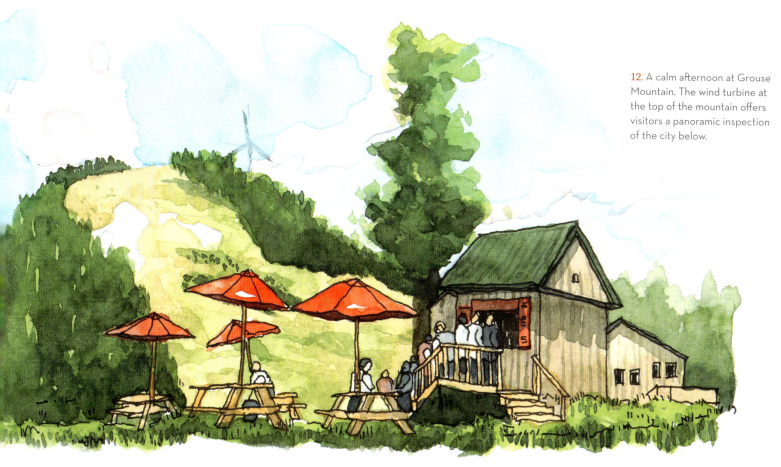

12. A calm afternoon at Grouse Mountain. The wind turbine at the top of the mountain offers visitors a panoramic inspection of the city below.

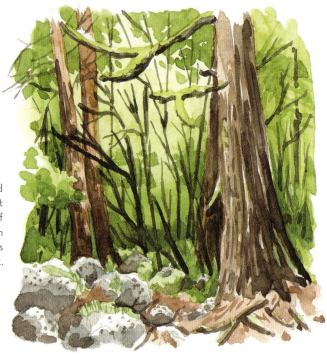

13. Variegated lichen coat the top of branches in Stanley Park's forest.

making was no less important than city building and Vancouver mayor David Oppenheimer declared that Stanley Park was to be "the finest park on the continent."[i]

Olmsted's Central Park in New York City is the quintessential example of "landscape architecture" —the notion of designing an entirely *constructed* landscape that *appears* natural. Stanley Park, on the other hand, had no landscape architects. Instead, Stanley Park is a *palimpsest*, a natural layering of history created by the constantly evolving relationship between the land and its inhabitants. With three thousand years of cultural influence, Stanley Park is also a vehicle for understanding the City of Vancouver's history and culture.

STANLEY PARK

This peninsula was once entirely covered by a forest of trees, but for the most part has been replaced by a forest of buildings. Urbanity now occupies much of the Lower Mainland. However, a part of the ancient landscape still survives in Stanley Park. On the map, the park appears like a green appendage protruding out of the peninsula, curling north toward the mountains. At almost the same size as downtown Vancouver, Stanley Park is the city's conjoined twin, sharing a common history while developing individual personalities.

The founding of Stanley Park dates back to the late 19th century, shortly after the opening of Frederick Law Olmsted's Central Park on Manhattan in 1857 and the completion of San Francisco's Golden Gate Park in the 1870s. In 1886, at the first council meeting of the newly established City of Vancouver, the young centre of one thousand people chose to turn one thousand hectares of the western peninsula into a park. To Vancouver, park

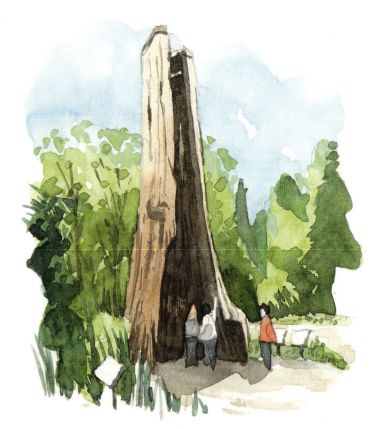

14. Stanley Park's 600 to 800-year-old Hollow Tree stands alone beside a parking lot with tourists taking photos inside it.

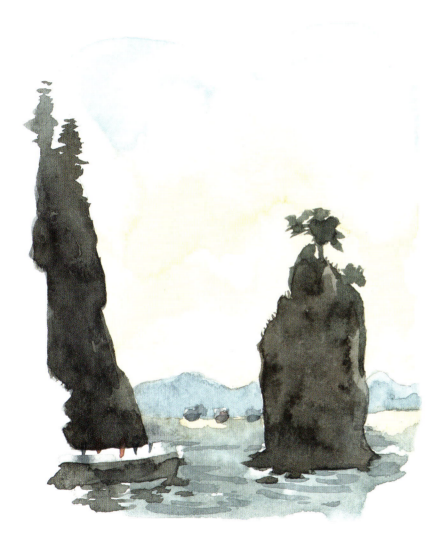

SIWASH ROCK

No visible attractions in Stanley Park have existed for as long as Siwash Rock, formed 32 million years ago from a volcanic fissure. Standing alone against the backdrop of distant mountains, a brave tree clings precariously to the rock, with roots gripping loosely to the ridges and cracks. When it first came into being, the rock was buried beneath sandstone that connected it to the shore. It took millions of years, with nature patiently sculpting and grinding, to become the solitary pillar we see today.

As the sun begins to set, crowds of tourists dismount from their bikes to take photos with nature's masterpiece. This rock has been one of the main attractions since the establishment of the park, but it has fascinated people for thousands of years.

15. The silhouette of Siwash Rock against the setting sun.

Human occupation in the Lower Mainland dates back ten to twenty thousand years and the earliest evidence of humans in Stanley Park dates to almost three thousand years ago. Several First Nations subsisted directly on the resources in the area, including the Musqueam, Squamish, and Tsleil-Waututh. One Squamish legend tells the story behind formation of Siwash Rock, where gods turned a young man named Skalsh into the rock as testament to his purity and commitment to fatherhood.

Skalsh continues to stand today, unfaltering in the largest storms. The legend of Siwash Rock is one of many stories First Nations have of the region, and while they were evicted from the peninsula upon establishment of the park, their long history in the area has, and continues to play, an undeniable role in shaping Vancouver's destiny.

In 2017, Vancouver Park Board Commissioner Catherine Evans proposed renaming Siwash Rock as part of Vancouver's reconciliation efforts. "Siwash" means "savage" in Chinook jargon, and the Squamish people have lobbied for years to have the name changed.[ii] The name has not been officially changed yet, but proposals include "Slhx̱i7lsh," ("Skalsh"), which means "standing man."

16. Canoes of different designs docked on Stanley Park after a morning race.

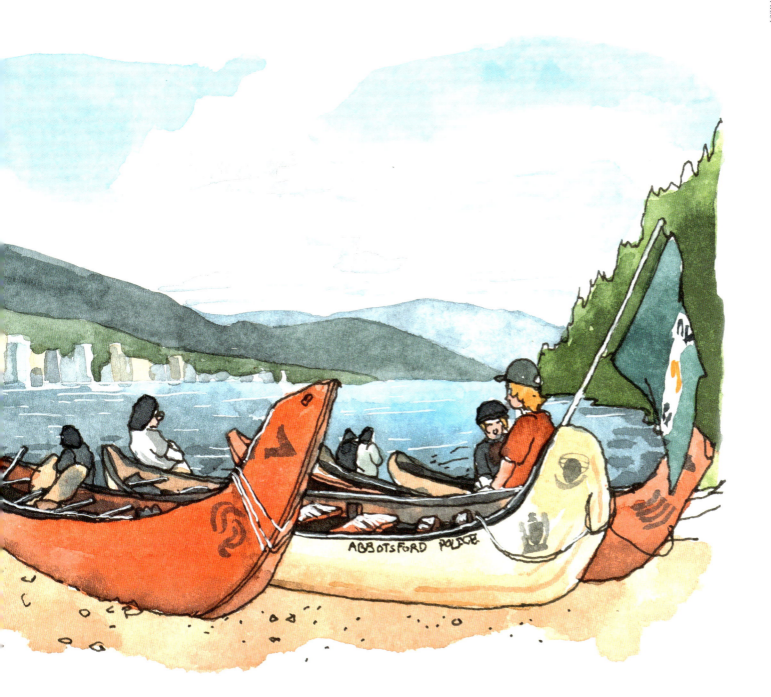

Like the rest of Vancouver, the museum is built on traditional and unceded First Nations land. According to Haida legend, the first people here were born from a clamshell discovered by Raven. This Creation Story is represented in a spectacular sculpture by Bill Reid which is displayed in the museum rotunda. With the abundance of natural resources in the region, local Indigenous people were able to develop a complex society with a belief that both animate and inanimate objects have spirits. From the animal carvings on totem poles to painted iconographies that decorate the sides of dugout red cedar canoes, the First Nations saw themselves as an integral part of nature and had an ethos of respectful coexistence with the natural world.

TOP LEFT 17. A solitary flag pole marks the end of UBC's Main Mall with North Shore Mountains in the distance.

BOTTOM RIGHT 18. From the reflective pond in the Museum of Anthropology garden designed by Cornelia Oberlander, the post-and-beam motif of the museum is most evident. A handful of totem poles are planted in the garden.

TOP RIGHT 19. Large panes of glass separating the rhythm of gateways allow natural light to flood the Grand Hall of the Museum of Anthropology, giving visitors an outdoor-like experience.

MUSEUM OF ANTHROPOLOGY

Many First Nations artifacts that were once scattered across the peninsula have been brought to the Museum of Anthropology at the University of British Columbia, where they are restored and put on public display. Sited on a promontory at the western edge of Vancouver, the museum is an architectural masterpiece designed by Arthur Erickson in 1971, and inspired by the Haida and KwaKiutl people of Vancouver Island, where these First Nations groups continue to live today.

Walking down from the terraced rose garden at the University of British Columbia, the striking roof of the museum rises as bars of concrete nestled in the primeval forest, set against the blue Pacific Ocean. Sunken and partially hidden behind trees, the post-and-beam-inspired edifice is a perfect canvas for the shadows cast by dancing foliage. Inside, a ramp guides the visitor through a dimly lit gallery to the Grand Hall.

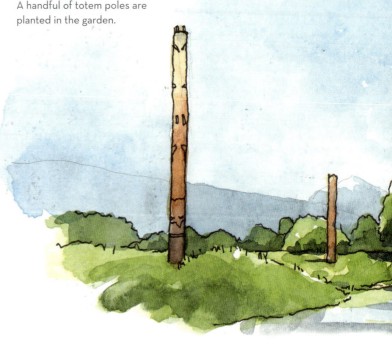

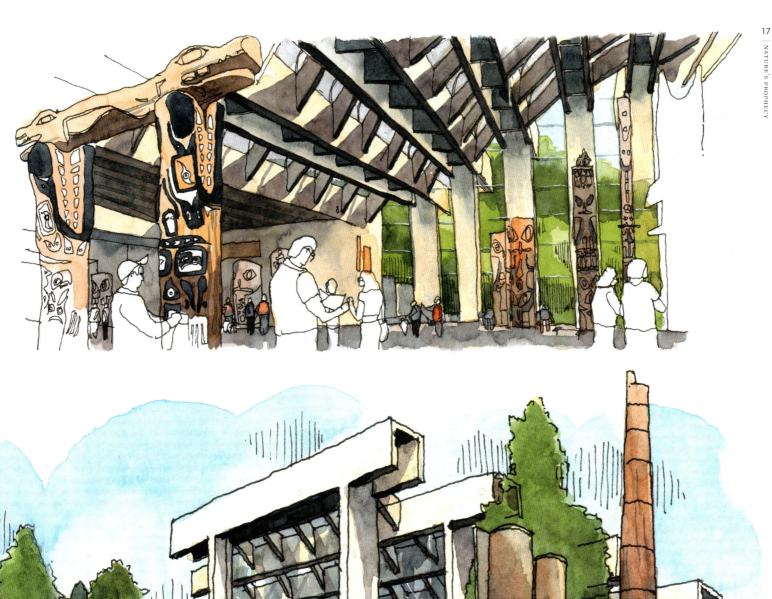
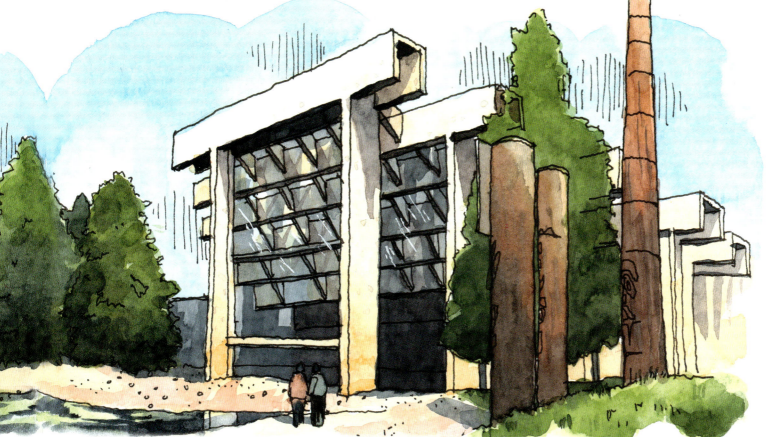

In 1492, Christopher Columbus arrived in present-day Bahamas and soon, Europeans would be exploring the eastern coast of the newly discovered continent. The influx of Europeans unintentionally brought infectious diseases like smallpox that killed millions of native inhabitants. Just as Europeans began to conquer and colonize the continent, the diseases they carried also gained momentum, spreading faster than the forces of colonization itself. By the time George Vancouver arrived in the Pacific Northwest Coast in 1792:

"The skull, limbs, ribs and backbones, or some other vestiges of the human body, were found in many places, promiscuously scattered about the beach in great numbers."[iii]

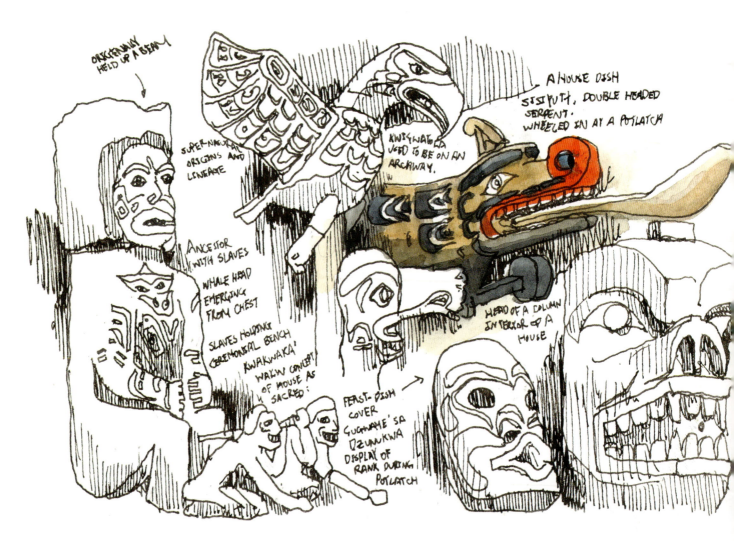

20. Some of the First Nations artifacts on display in the museum.

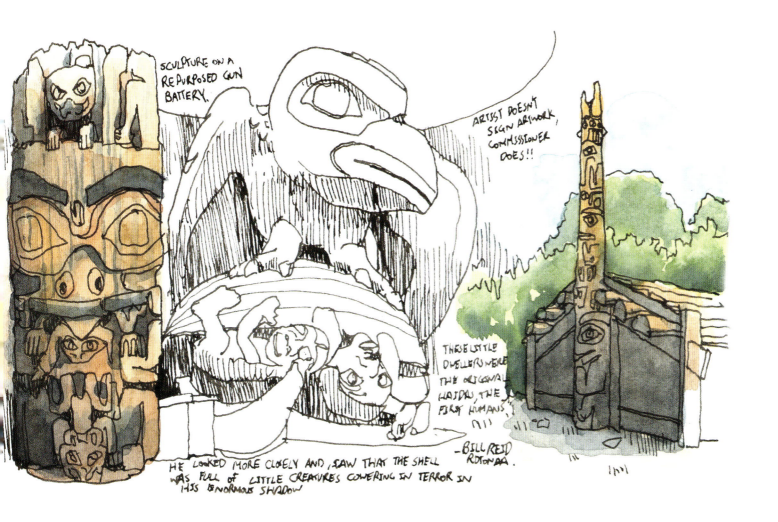

INDUSTRY OF MAN

21. A tree stump along one of the trails in Stanley Park. Rather than a victim of logging, this tree probably fell during the record-breaking storm in 2006.

BROCKTON POINT

Biking along the edge of Stanley Park, I arrive at Brockton Point, where a red and white lighthouse gave off a harsh glare in the blazing sunlight. The heat breeds mirages out over the water, where smallpox survivors saw George Vancouver and his crew sail into the Burrard Inlet in 1792. There is much text attributed to Vancouver's voyage but perhaps his most memorable description of the region's potential is this:

"The serenity of the climate, the innumerable pleasing landscapes and the abundant fertility that unassisted nature puts forth, require only to be enriched by the industry of man with villages, mansions, cottages and other buildings, to render it the most lovely country that can be imagined."[iv]

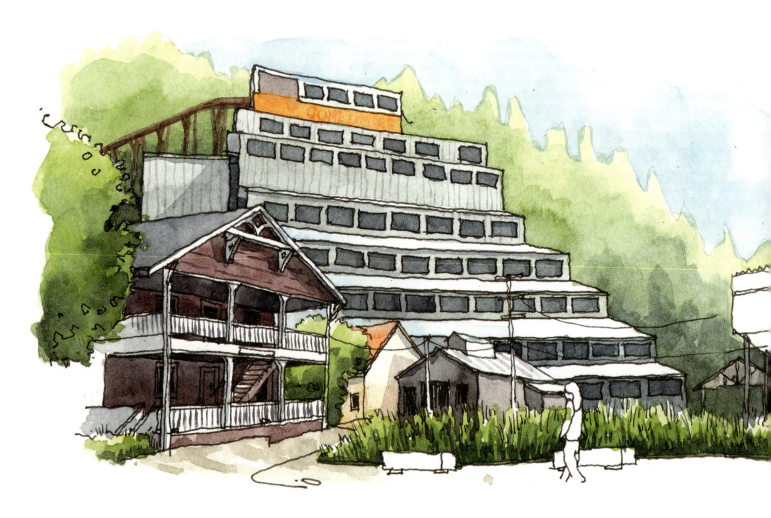

Not only was it beautiful, to him the peninsula was a *terra nullius,* a no man's land prime for colonization. Despite this, the region remained mostly free of Europeans until 1858 when gold was found nearby in Fraser Canyon, flooding the region with prospectors looking to make a fortune. Most returned home when the Gold Rush came to an end, leaving behind vestiges of a business centre called New Westminster, complete with stragglers looking to find new opportunities. To these folks, nature was property. They saw minerals to be mined and forests to be chopped down. Most important, they saw that the extensive coastline, indented with deep bays and fjords, would make perfect harbours for vast fleets of merchant ships.

Behind the Brockton Point Lighthouse in Stanley Park., the thick forest that populates much of the park ends at the edge of a manicured field. Here, people enjoy the sudden respite from the forest; some lay on the grass while others throw frisbees. Although calm, this field is the footprint of industry's war against nature: it is a clearing made by Edward Stamp in 1865 when he attempted to construct a sawmill on the peninsula. Rough currents would force the mill to move east to what is now Gastown, consequently giving birth to Hastings Mill and an industrial settlement.

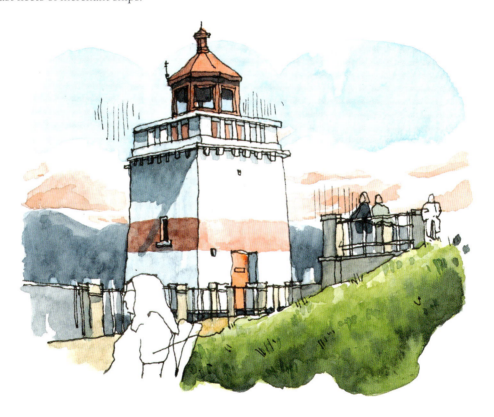

BOTTOM LEFT 22. The Britannia Mine Museum in Squamish grasps the slopes in between the mountain and the sea. In the late 1920s, it was the most productive copper mine in the British Empire.

TOP RIGHT 23. The current Brockton Point Lighthouse was built in 1915 but a lighthouse has been in place since 1890, a year after the dedication of Stanley Park.

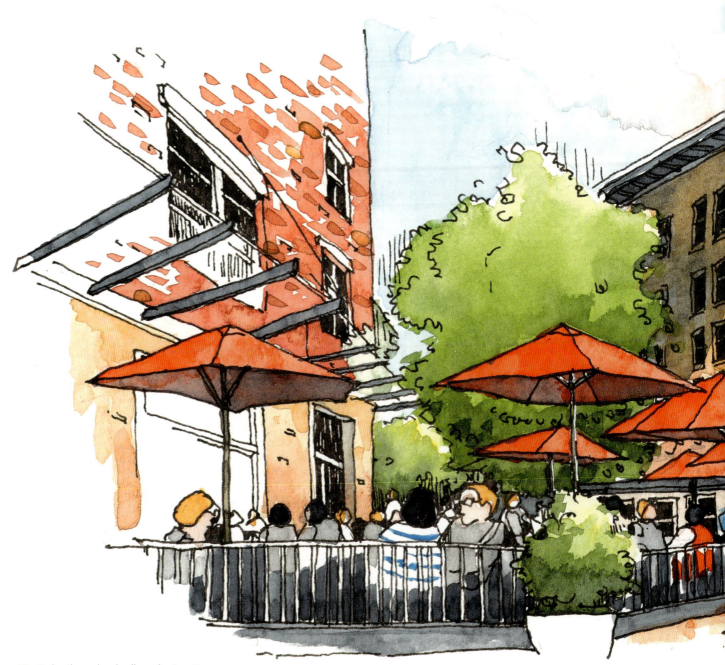

24. Under the red umbrellas, a bar's patio is packed with people at the intersection of Water and Carrall streets.

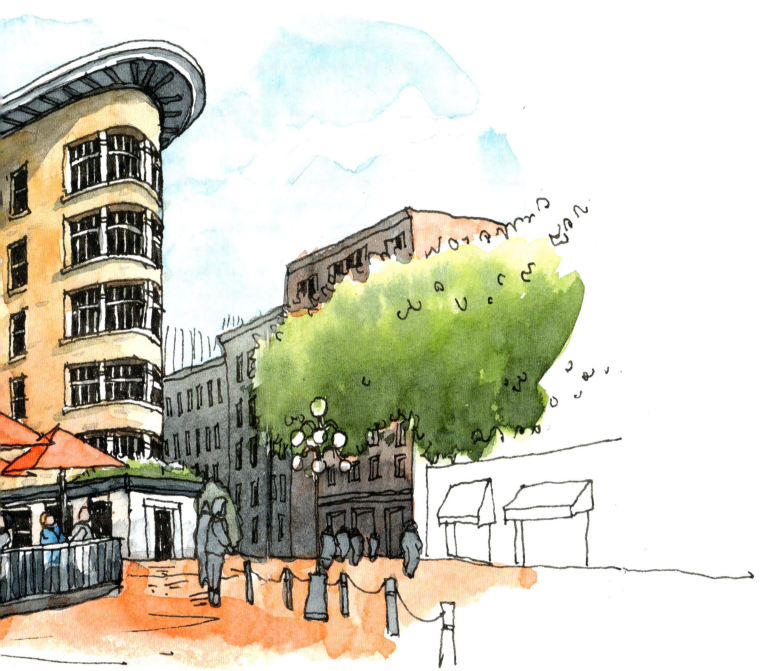

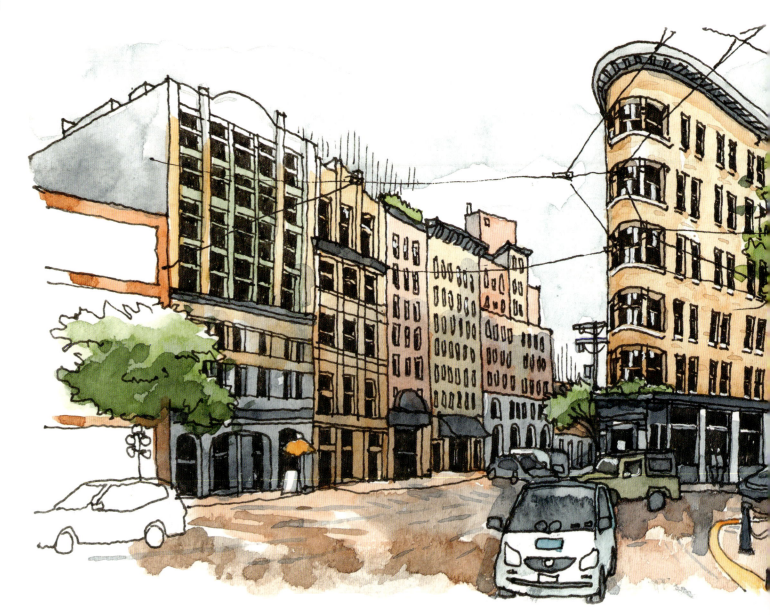

25. On a cloudy afternoon, the steely-grey sky desaturates the vibrant hues of orange and red bricks of Gastown.

GASTOWN

A medley of boutiques, restaurants, and souvenir stores line the historic façades of Gastown. At the confluence of Water and Carrall streets, a bronze statue of a man seems a curious observant at the intersection. With his arms half raised, it looks as if he is choreographing the rhythm of cars and people. Wide-eyed tourists snap photos from all angles.

An inscription at the bottom of the statue reads:

GASSY JACK
1830-1875
THE FOUNDING FATHER OF GASTOWN

The story of Gastown starts with the story of the man known as "Gassy Jack" (his legal name was John Deighton). The nickname "Gassy" stems from the 19th-century term "to gas," which meant "to talk a lot." In 1867, with little more than six dollars, a few pieces of furniture, his wife, and a dog, Deighton appeared in a dugout canoe on the south side of Burrard Inlet next to Hastings Mill. With help from mill workers, Deighton opened the Globe Saloon within twenty-four hours of his arrival, and the first bar in the industrial settlement was born. Little did he know, a fledgling community would spring up around his establishment and by 1870 the settlement was officially designated as the townsite of Granville. Locally, however, it was known as Gastown.

TOP RIGHT **26.** Global Saloon's new incarnation—another bar stands in place of where Deighton's bar once prospered.

BOTTOM LEFT **27.** A backstreet facing the rail-yard runs along the northern edge of Gastown.

BOTTOM RIGHT **28.** The streets of Gastown were not laid down in a grid and there are many spots where streets meet at acute angles to create flatiron buildings.

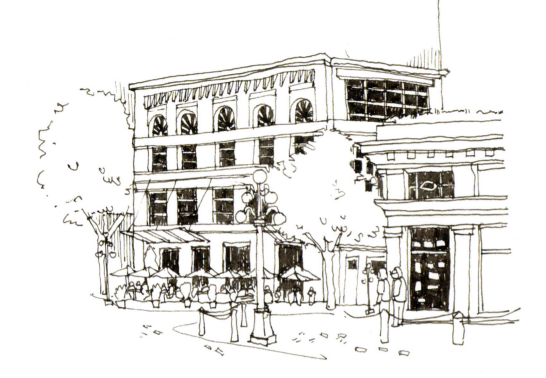

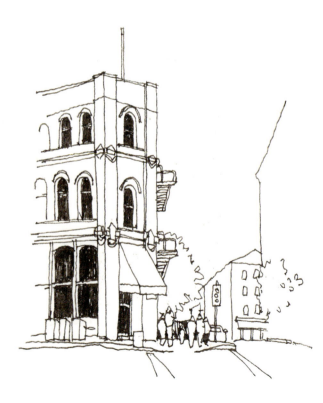

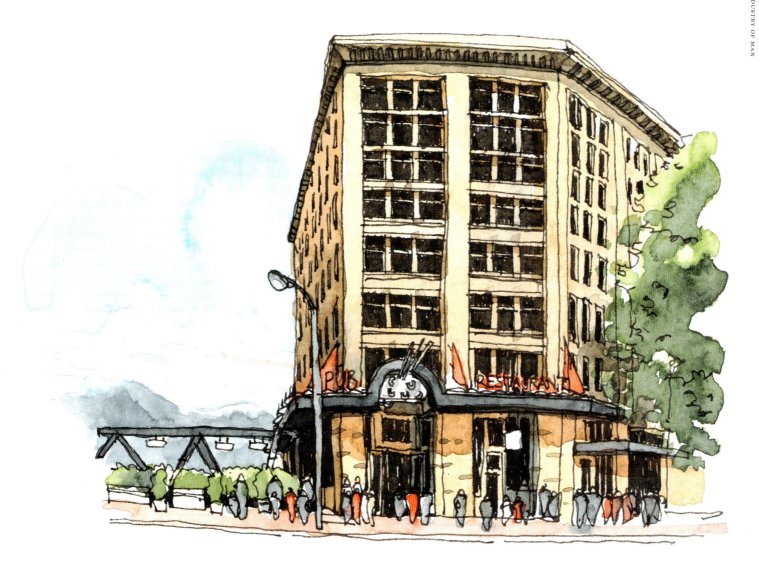

29. The Landing building is an original tall wood building built in the early 1900s as a warehouse serving gold-rush miners. Today, it is a prestigious office building with a local brewery and bar on the ground floor.

The Globe Saloon has long since been demolished but Gastown remains lively and popular year-round. Once a week, the fashion-boutique-filled Gastown is transformed into its alter-ego and Vancouverites from across the city arrive for a drink. Even on a rainy winter night, the uneven cobblestone roads are filled with a profusion of "gassy" locals celebrating the sights and tastes of this hot-spot destination.

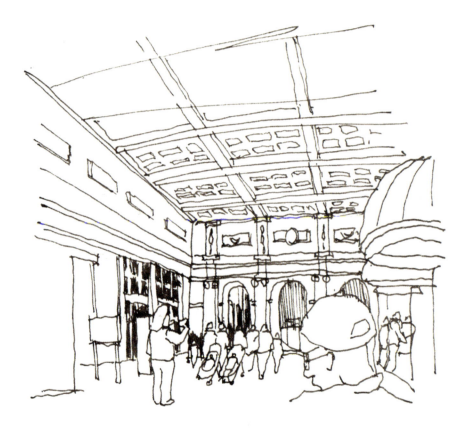

TOP 30. Large crowds rush by at Waterfront Station's main concourse.

RIGHT 31. Built in 1914, Waterfront Station was established by the Canadian Pacific Railway as the Pacific terminus for transcontinental passenger trains. Today, it is a major intermodal public transportation hub with connections to the Skytrain, Seabus and West Coast Express.

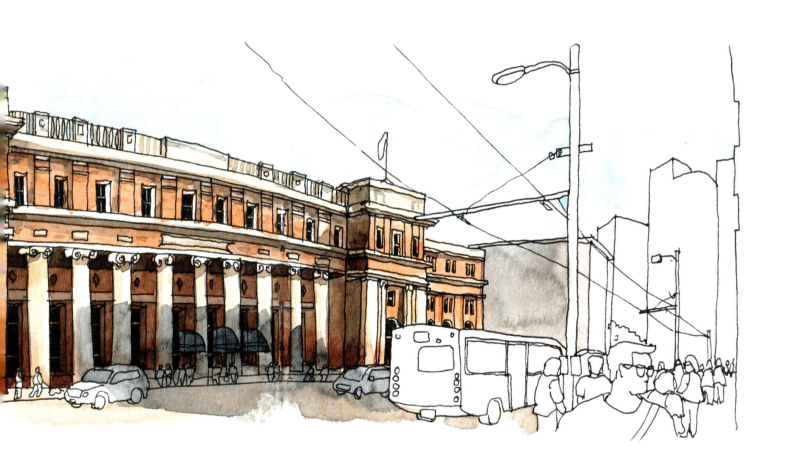

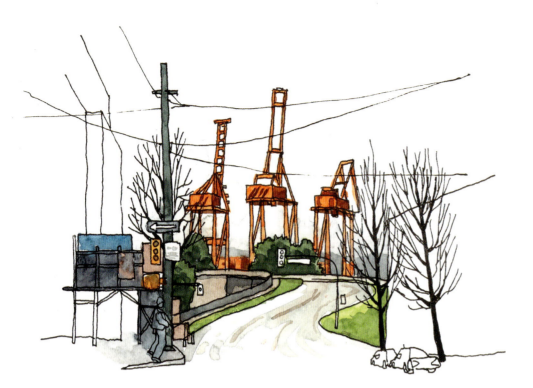

32. Gantries at the Port of Vancouver seen from Main Street.

Just as I finish painting the sodden brick buildings, the clattering sound of passing trains guides me to a street at the edge of a rail-yard. Beyond the train tracks, the Pacific Ocean appears like a band of blue with small streaks of cruising cargo ships. To the right, a row of orange cranes tower over the ocean with their gantries sliding side to side, welcoming and bidding farewell to brightly coloured shipping containers. At the end of Jack Deighton's life, he told an old miner with prophetic wisdom, "You and I may never see it but this inlet would make the nicest of harbours. It will be a port someday."[v] Today, Vancouver is the largest port in Canada.

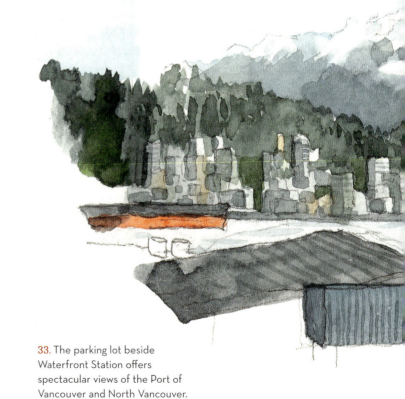

33. The parking lot beside Waterfront Station offers spectacular views of the Port of Vancouver and North Vancouver.

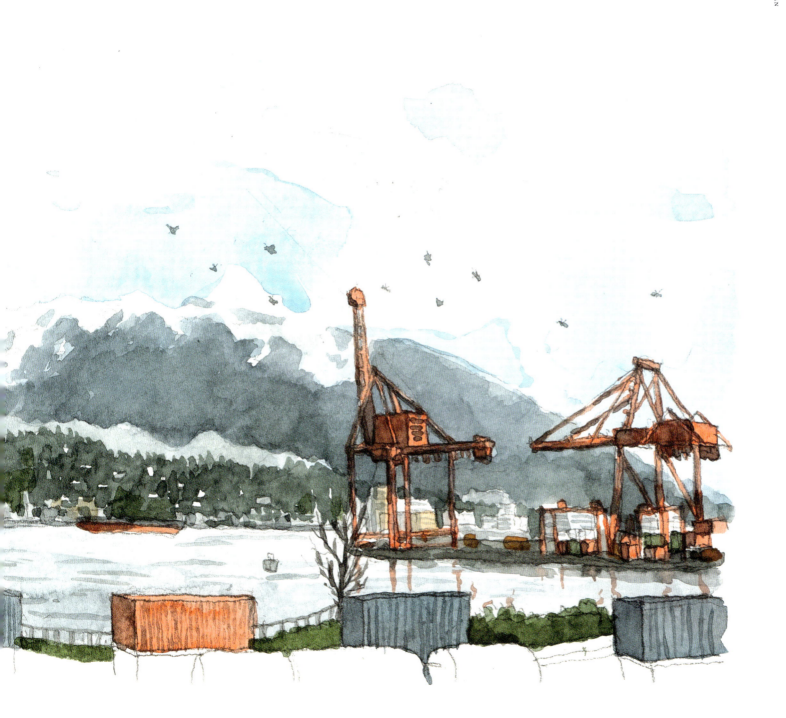

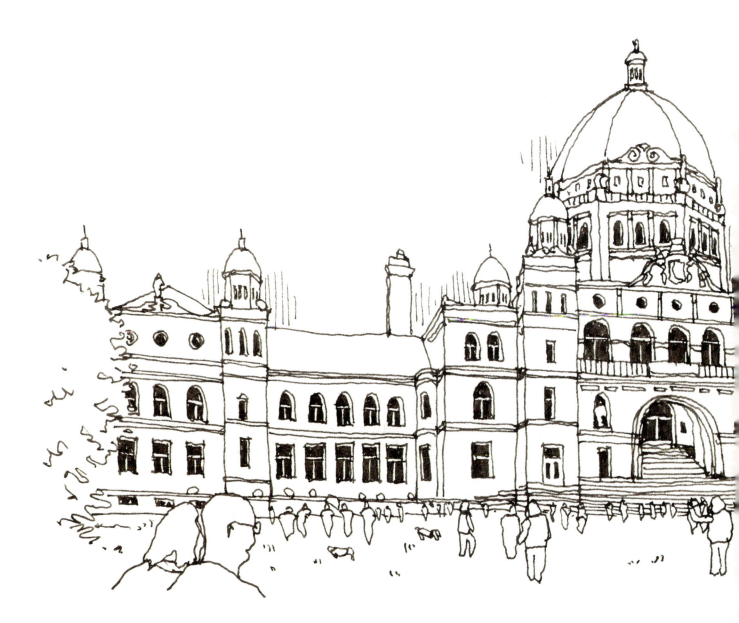

34. Victoria is the capital city of British Columbia and its Parliament Building was built in 1893. You can get here by ferry in a little over four hours.

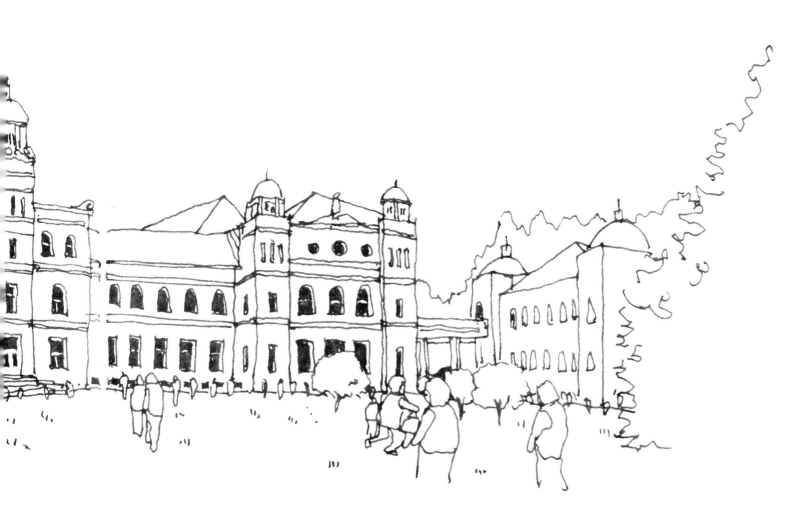

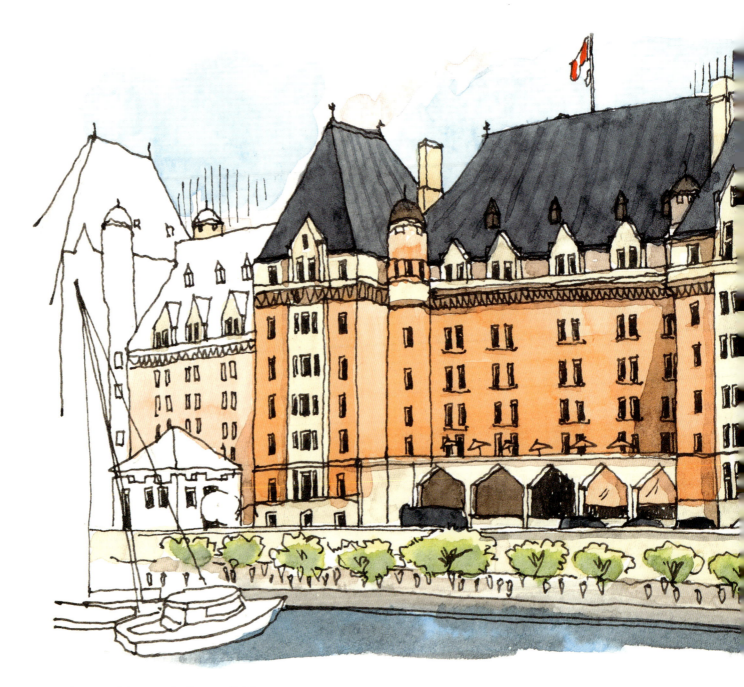

35. Another icon of Victoria is the Empress Hotel. The Châteauesque-styled building overlooks Victoria's inner harbour.

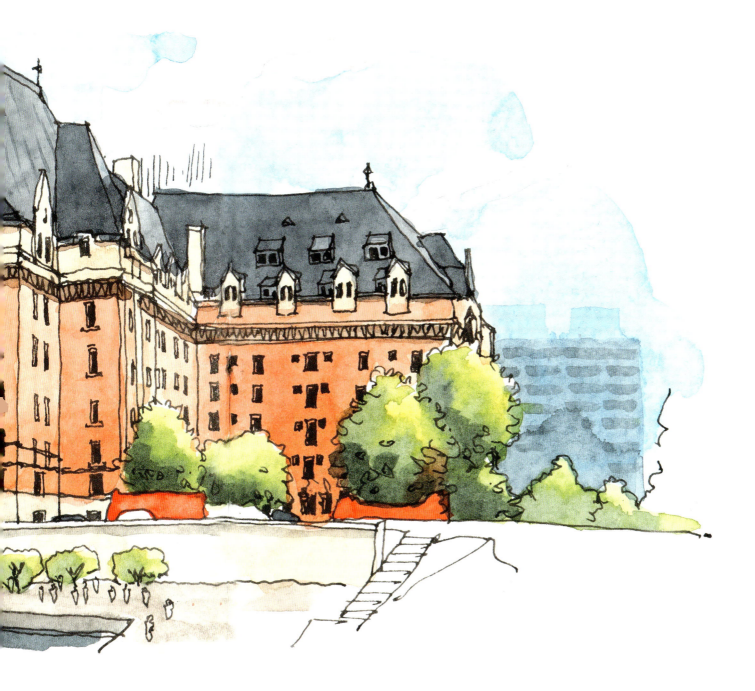

Although the port offered efficient shipping to routes in Asia and the western coast of the Americas, it was the transcontinental railway that made shipments to Europe and the eastern coast of North America practical. Prior to the completion of the Panama Canal in 1914, seafaring to eastern destinations involved a long and treacherous route off the southern tip of the Americas. The decision to place the terminus of the Canadian Pacific Railway on this peninsula brought about the founding of the City of Vancouver in 1886 and initiated a logging spree that cleared a vast amount of land. As the primordial forest fell to the loggers' axe, an exposed landscape ripe for city-building was born.

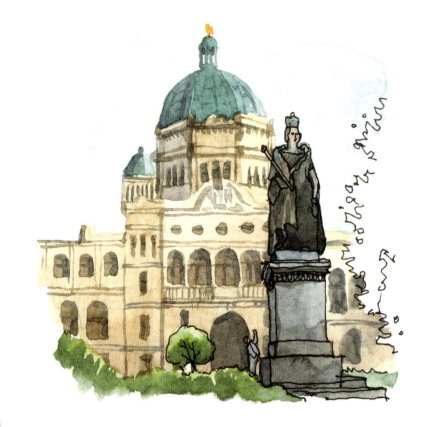

TOP RIGHT
36. A statue of Queen Victoria in front of the Parliament Buildings in Victoria with a golden statue of George Vancouver at the top of the Parliament's dome.

BOTTOM LEFT
37. Vancouver's City Hall moved out of downtown in 1936, when the current City Hall was built at the intersection of Cambie Street and West 12th Avenue.

YALETOWN

City building reached a flash point in the summer of 1886, when a brush fire set to clear land spread out of control because of a strong gale. In less than an hour, the flames engulfed the newly built wooden city and Vancouver burnt to the ground. The peninsula became a *tabula rasa,* a blank slate yearning for a new beginning. In mere weeks, a new Vancouver rose from the ashes: this time, it was a city of stone and brick, complete with modern water, electricity, and streetcar systems.

TOP LEFT 38. Smoke-induced sunset at noon in Yaletown after a week of wildfires in the Rocky Mountains.

TOP RIGHT 40. Kamloops was a lot closer to the wildfires and its streets were coated in a premonitory tinge of yellow.

BOTTOM LEFT 39. What appears to be an old Vancouver Trolley Company bus on Keefer Street is far from historic. It is a disguised tour bus.

While no fire has since had a comparable effect on Vancouver, the frequency of wildfires nearby has increased as a result of progressively warmer and drier summers. Coincidentally, the summer of 2017 was one of the driest in the city's history and numerous wildfires spread uncontrollably through the Rocky Mountains and the forests of northern BC. During late summer, the smoke from distant fires coated Vancouver in a cautionary tinge of cadmium yellow.

The air grew so thick that it became repellant. Even regular patrons of Yaletown's popular patio bars were forced off their stools to find refuge where the air was fresher. Above the uncharacteristic calmness, the sun was a diffused circle of white, too weak to cast a shadow on the neighbourhood. Even the century-old pitted and sooted bricks were overshadowed by smoke.

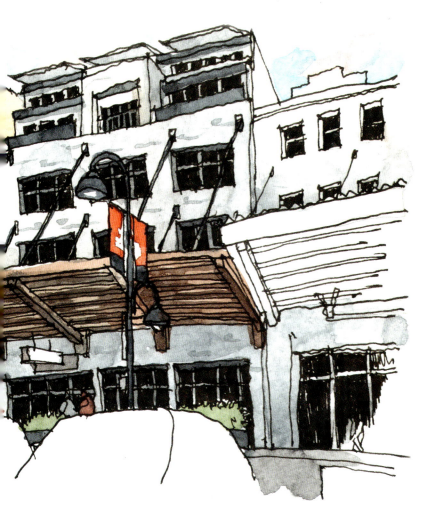

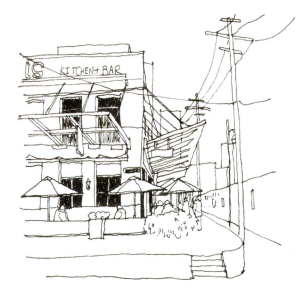

TOP LEFT 41. The former warehouses have become a hotspot for restaurants and bars. The brick buildings, have been modified unapologetically with terraces and steel penthouses.

TOP RIGHT 42. Enormous steel canopies jut out of the formidable brick façades, casting sharp shadows onto the patio.

BOTTOM RIGHT 43. The elevated loading docks that once characterized Yaletown's warehouses have been transformed into chic patios.

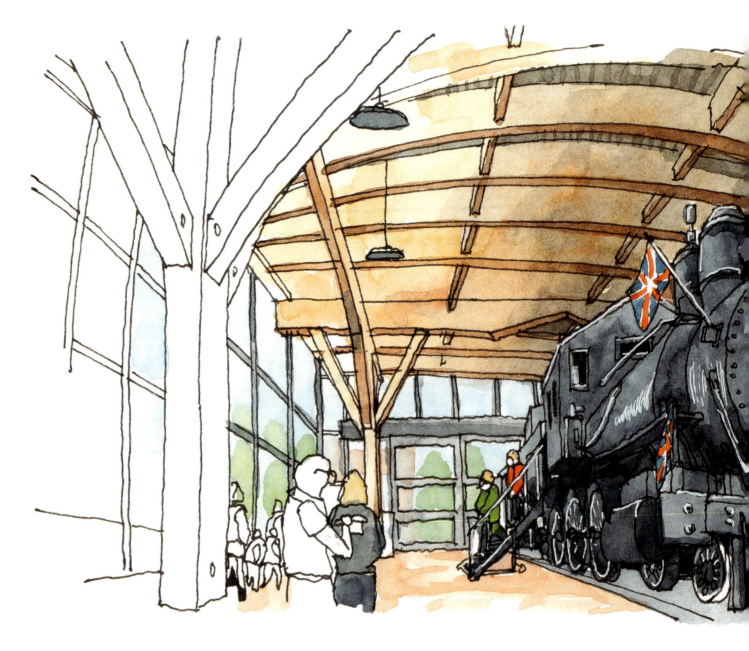

Without the distracting glare that accompanies a sunny day, the glass pavilion at the Yaletown Roundhouse seemed to melt away while Engine No. 374, the pioneering locomotive that brought the first transcontinental passenger train into Vancouver, acquired a grand presence on the street. A group of children lined up beside the engine, taking turns climbing the precarious steps and pulling the rope that rings the bell. With each gentle pull, the swinging clapper hit the mouth of the bell and the metal resonated to produce the same ring heard by the first transcontinental passengers in the Spring of 1887, when the engine first arrived on this peninsula.

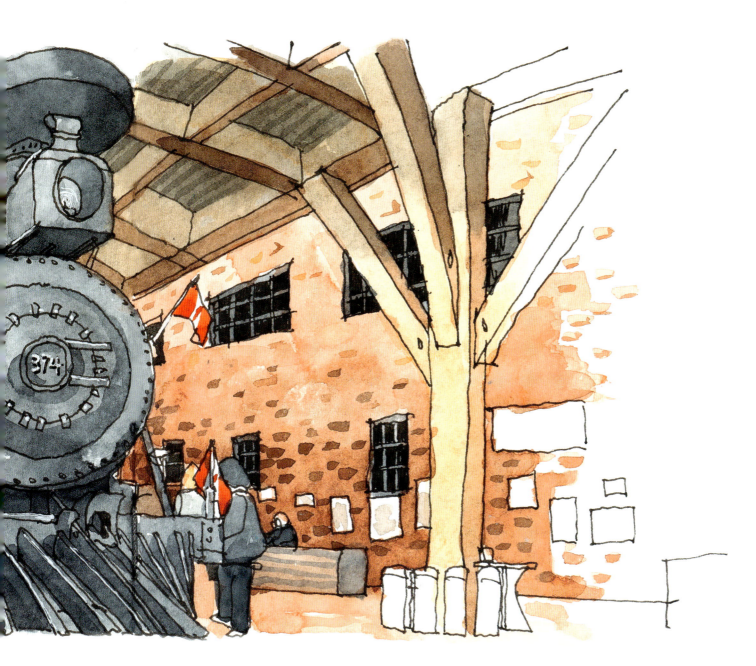

TOP 44. Engine No. 374 commands the interior of the Yaletown Roundhouse pavilion with tourists peeping in from the street.

45. Not only is Chinatown a district for tourists, it also appeals to locals with markets that sell a variety of fresh produce. Many of these markets extend out onto the sidewalks, saturating the streets with a colourful cornucopia of fruits.

CHINATOWN

Spanning the two ends of Canada, construction of the transcontinental railway was one of the most laborious endeavours undertaken by the young nation. With some 17,000 Chinese workers recruited for their cheap manual labour and willingness to perform dangerous tasks, building of the railroad is the most commonly cited example of how the Chinese contributed to the making of Canada. In reality, Chinese influence in this region runs far deeper. From gold miners during the Fraser Valley Gold Rush to mill workers at Hastings Mill, the Chinese–who first arrived on Vancouver Island in the late 1770s–were key players in the industrialization of the peninsula and the growth of this city.

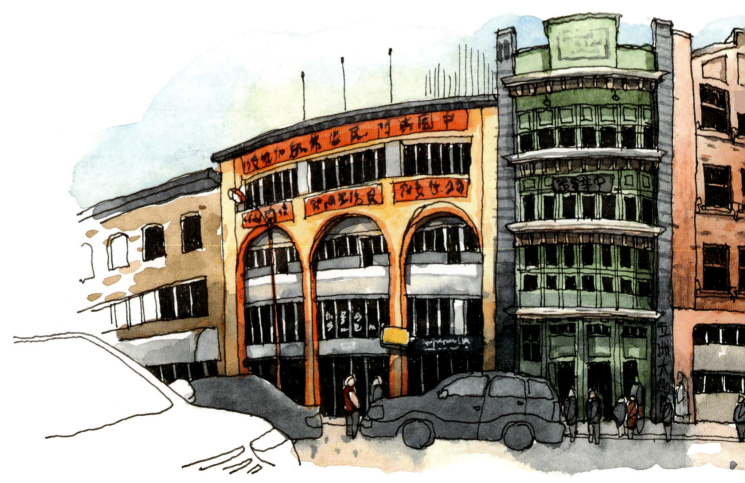

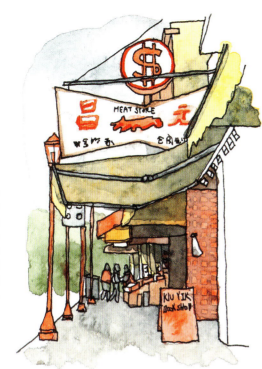

46. The neon sign for "Dollar Meat Store", an old-guard butcher shop, interrupts the rhythm of yellow-and-red awnings.

East Pender Street, the main artery running through Chinatown, is lined with eccentric shops overflowing with the colours and smells of tropical fruits and exotic herbs. Yellow-and-red awnings extend over the sidewalks, overlaying their vibrant hues onto the otherwise dull concrete walkways. From hand-made dumpling wrappers to the best pineapple buns in town, these were the shops where my grandmother and I used to go every Sunday afternoon.

BOTTOM LEFT 47. A row of colourful heritage buildings in Chinatown. The green building in the centre was built for the Chinese Benevolent Association on East Pender, established in 1895 to defend the Chinese community against anti-Asian legislation.

BOTTOM RIGHT 48. This monument in Chinatown is dedicated to the historic achievement of the Canadian Chinese, including their bravery in WWII and their invaluable work on the Canadian Pacific Railway.

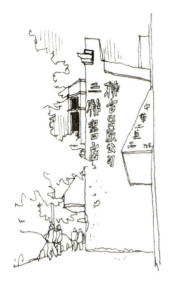

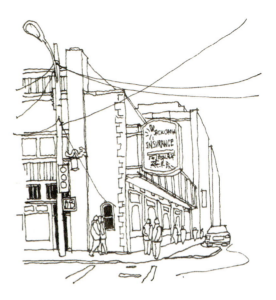

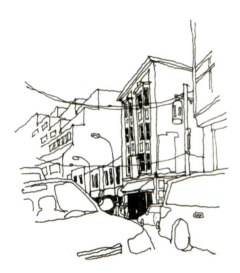

Above the canopy, two tiers of green-glazed roof tiles jut out from the brick façade, proud reflections of their Chinese heritage. Beside it, a row of decorative Grecian Ionic columns stand between oversized red spandrels covered in Chinese characters. Looking down the street, the façades of Chinatown are a curious mix of styles, each a reinterpretation of the balance between Western and Chinese architecture. At the top of the Wing Sang Building, embossed numbers date the buildings back to the end of the 19th century, when Chinese presence in the region crystallized and Chinatown emerged on Carrall Street and East Pender Street.

TOP LEFT 49. The lack of strict zoning requirements historically meant that the buildings in Chinatown do not follow a specific set-back from the street. This has resulted in dynamic sidewalks that are constantly changing widths.

BOTTOM LEFT 50. Like many other buildings in Chinatown, the Keefer Rooms building contains retail shops on the ground floor with small apartments above.

TOP RIGHT 51. Sam Kee Building on Pender Street is the "shallowest commercial building in the world."[vi] The Sam Kee Company purchased a standard lot facing Pender Street but in 1912 the city assumed part of it to widen the street. Sam Kee decided to build on the sliver of land anyway.

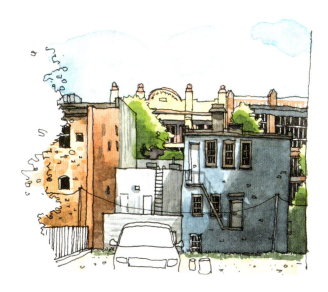

52. A vacant plot of land in Chinatown awaits a new destiny.

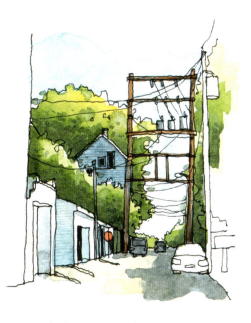

53. A back street in Strathcona, the residential neighbourhood beside Chinatown.

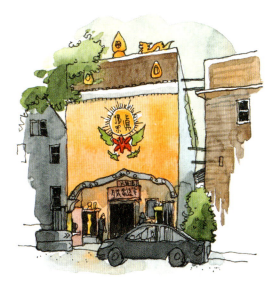

54. Strathcona used to be home to a Japantown. However, the Japanese population in the area shrank after WWII, when Japanese-Canadians were branded as enemy aliens and relocated to internment camps. Nevertheless, some parts of the Japanese neighbourhood survived: this orange Buddhist temple is one of them.

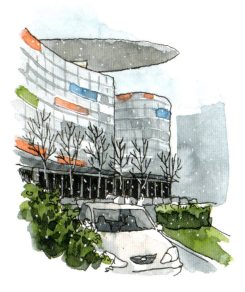

55. Over the last decade or so, Chinatown has been hijacked by Richmond, a city beside Vancouver where half of its residents are ethnically Chinese. Aberdeen Centre is one of the main malls in this burgeoning Asian neighbourhood—its interior reminds me of the malls I grew up with in Hong Kong.

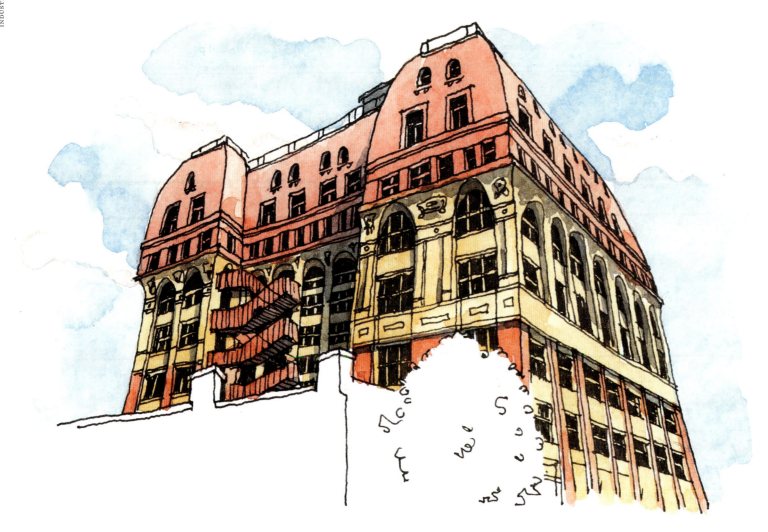

56. From Homer Street, the back of the Second Empire-style Dominion Building appears bulky.

DOMINION AND WORLD BUILDINGS

Completion of the transcontinental railway brought new hope to the peninsula, and with hope came speculators. With unbounded optimism, wealthy Europeans flooded the city with investments fuelling Vancouver's booming economy at the end of the 19th century. Capitalism made Vancouver a wealthy and vibrant cosmopolitan. Driven by the burgeoning economy, a construction frenzy swept through the peninsula, resulting in much of what we see in the historic districts

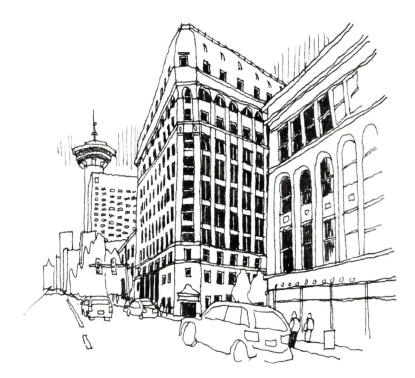

today. However, no two buildings better express Vancouver's early 20th-century industrial success more than the Dominion Building and the World Building—to be sure, their names alone denote commercial power and prowess.

The Dominion Building often appears in the distance as a bloated beaux-art block with a fire escape clinging onto its eccentric façade. But when approaching the building from the east, the Dominion Building emerges from rows of four-storey stone façades to command an entirely different presence. Two faces of the building meet at an acute angle, inscribing the edifice's presence onto the intersection of Cambie and Hastings streets. No longer hidden behind its neighbours, the building flaunts its regal façade with pillars of red bricks thrusting skyward. Completed in 1910, with a height of fifty-two metres, this was once the tallest building in the British Empire.

Despite its name, the Dominion Building was not bankrolled by an individual company. Instead, Imperial Trust, the company that first proposed the building, made use of public funding and a merger with Dominion Trust to cover construction. Promoted as "a landmark in the city, and object of pride to every loyal citizen," the building was born of a collective desire to place Vancouver in the neck-and-neck race for the tallest building in the world—and the associated bragging rights.[vii]

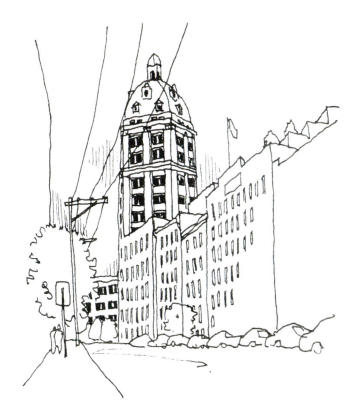

TOP 57. From the intersection of Cambie and Hastings streets, the Dominion Building acquires a regal flair—as a slender flatiron.

BOTTOM 58. The World Building was first built to house The Vancouver World, a newspaper company. Its height came from the owner's desire for the building to be visible throughout the newspaper's circulation area. In 1937, The Vancouver Sun, another newspaper company, bought the building and renamed it the Sun Tower.

While the Dominion Building continues to stand as a glorious display of wealth, its title as tallest building in the British Empire only lasted two years before the neighbouring World Building (or the Sun Tower) overtook it. Nine partially naked female figures, reminiscent of a Mucha painting, support its cornice in a seductive display. Above them, the bulky base of the building is topped by a tower, the uncontested symbol of power with soaring lines reaching for heaven. As the sun travels across the sky, the tower's long shadow sweeps across the city, raising eyes skyward wherever it lands.

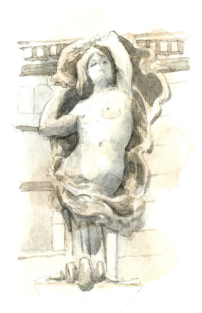

TOP 59. One of nine sculpted female figures supporting the Sun Tower's cornice.

RIGHT 60. Walking through Gastown, unobstructed by glass towers, Sun Tower continues to dominate the skyline.

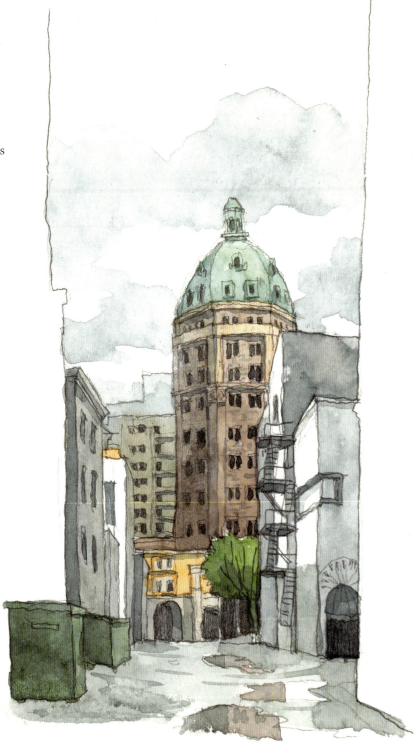

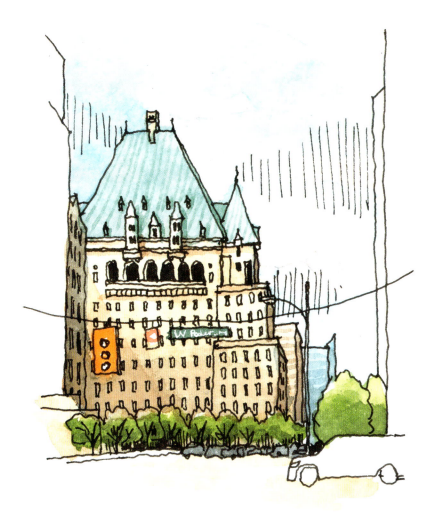

HOTEL VANCOUVER

Hotel Vancouver is another of the city's historic edifices. Every morning, as I look out of my grandparents' apartment, its enormous patinated green copper roof gleams in all its flawless beauty. It's hard to imagine that during the Great Depression, only its unfinished, bare steel frame stood over the city—a hollow monument to the city's dire financial straits. Unlike the Dominion Building and World Building that meld in with the historic urban fabric, the chateau-styled hotel stands in stark contrast to its 21st-century surroundings. From across the street, looking up at the entrance, the bas-relief of a locomotive and an ocean liner pay homage to contemporary technologies while a stone carving of Hermes, the god of commerce, stares disconcertedly into the distance. It was as if he knew Vancouver's industrial prowess was reaching the edge of a precipice.

61. Hotel Vancouver was started by the Canadian National Railway in 1929 to serve the passengers of Canada's expanding rail network. Although the Depression delayed its construction and it was not completed until 1939, it stood as the city's tallest building for 33 years.

FROM RESOURCES TO REVELRY

62. Opened in 1911, the Vancouver Rowing Club is Stanley Park's first permanent club facility. Prior to this, several sports fields, including the Brockton Oval made from Edward Stamp's clearing, provided locals with recreational space.

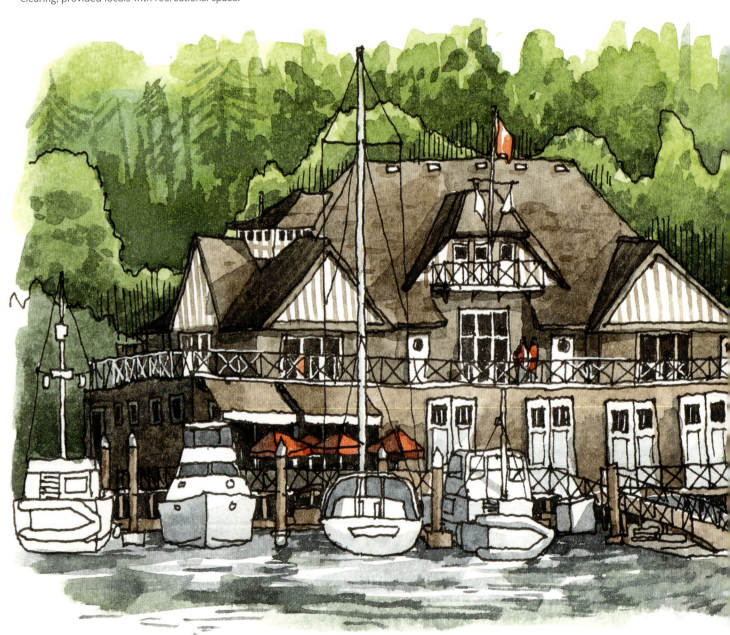

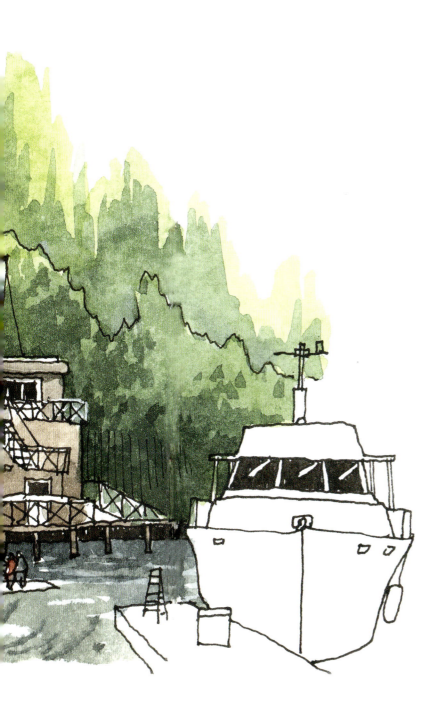

ROWING CLUB

Enveloped in the lucid air of a Saturday morning, Stanley Park awakens with early-bird joggers and cyclists arriving before the inevitable afternoon crowd. Nature, seen in the past as an exploitable collection of commodities, has now become Vancouver's signature feature, with sailboats scattered out over the water with raised white masts that nod to the rhythmic ocean waves. Behind them, the Vancouver Rowing Club, the first permanent club facility in the park, was an early example of how industrial space would overlap with leisure space in the decades to follow.

Behind the Rowing Club is a rich sap-green forest, where a network of narrow trails running between exposed tree roots guide hikers to serene corners of the peninsula. The trails were born during the logging boom from logs that skidded down these passageways toward the ocean. The logs slowly sculpted away the vegetation and grooved ruts into the soil. Today, however, this old commercial path has been usurped for recreation. Now it's the feet of hikers that maintain these trails.

TOP 63. Apart from sailboats, many yachts are docked in the harbour.

SEAWALL

A pathway situated a few metres above the ocean slips behind the Rowing Club and sweeps along the edge of the park's serpentine shoreline to form the Seawall. With the park on one side and the Pacific on the other, the Seawall helps shed light on why Vancouver's original motto was, "By Land and Sea We Prosper."

Kissing the jagged edge of the peninsula, the width of the Seawall varies to accommodate the occasional tree and rock that bluntly protrude out from the concrete paving. At the same time, restless waves slam hard against the Seawall, spraying water across the crisp summer air. What started as a pragmatic defence against the waves in 1918 has grown into a seaside boardwalk, and the waves that once eroded the defenceless foreshore have become a cooling mist. After decades of industrialization, the Seawall reinforces Vancouver's new relationship with nature, offering magnificent vistas over land and sea.

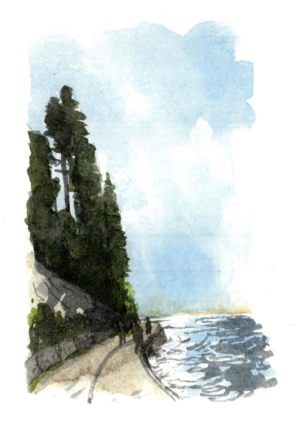

TOP RIGHT
64. The Seawall runs between the lapping waves of the Pacific and the steep cliffs of Stanley Park.

BOTTOM LEFT
65. The Seawall is split into two paths, one for pedestrians and one for cyclists. However, this was not always the case. In the 1970s and 80s, cycling was banned on the seawall.

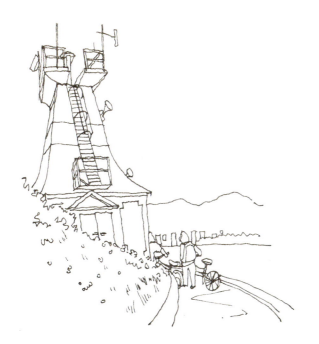

Benches are placed at irregular intervals along the Seawall, inviting pedestrians to sit and appreciate the expansive view. Bearing a metal plaque inscribed with a name, each bench pays tribute to a park supporter. At the same time, the location of the benches speak not to an objective beauty but to a place made special by personal acquaintance. My grandfather likes to sit on these benches for hours, watching the seagulls float on the water. And he hopes to dedicate a bench to share his favourite view with the rest of the city someday. To be sure, these Seawall benches weave together a narrative held together by the collective memories of countless people.

TOP LEFT

66. Prospect Point is located at the northern tip of Stanley Park. A lighthouse has been sited here since the late 1800s. Prior to the erection of the lighthouse, shipping accidents were frequent, giving rise to the nickname "Calamity Point."

BOTTOM RIGHT

67. The SS *Beaver* crashed onto Prospect Point in 1888 and was the catalyst for the creation of the lighthouse. Many remnants from the Beaver are housed in the Vancouver Maritime Museum in Vanier Park.

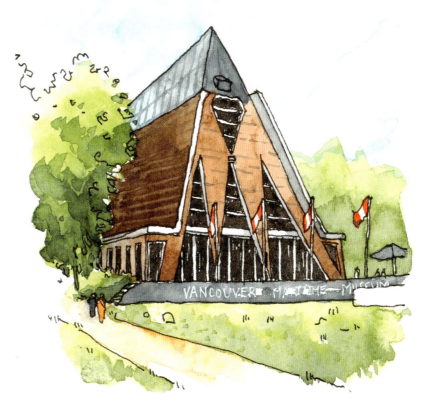

LOST LAGOON

The muffled roar of traffic on the Stanley Park Causeway can be heard from Stanley Park's Lost Lagoon. In its natural form, the lagoon was volatile and unpredictable. During low tides, it became an "unsightly, and actually smelly" tidal flat and during high tides, water from Coal Harbour flooded the basin, divorcing Stanley Park from the hectic city.[viii] It was the creation of the causeway between 1916 and 1926 that tamed the fickle lagoon and married it to the thriving metropolis, where by then more than two-hundred-thousand people lived.

Just as the city penetrated into the park, nature crept into the city. During the construction of the causeway, Virginia creepers began to cover the brick and terracotta façades of the Sylvia Hotel just a kilometre away from the lagoon.

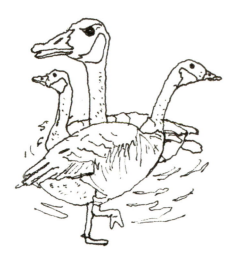

TOP RIGHT
68. Seen from Morton Park, only a small portion of Sylvia Hotel's Virginia-creeper-covered façade can be seen. It was once the tallest building in the West End, until superseded by apartment buildings in the 1960s.

BOTTOM LEFT
69. July is the hatching season for Canada Geese and the trails beside Lost Lagoon are taken over by goslings waddling beside their protective parents.

MARINE BUILDING

Deeper in the city, at the foot of Burrard Street, West Hastings Street curves southward to follow the irregular shoreline, unwittingly aligning the Marine Building to the centre of the road. In the morning light, the building's girth and imposing stone walls display a solidity and stability that is unlike any modern office building I have seen.

70. Marine Building aligns monumentally to the centre of West Hastings Street.

Rather than the ornate crown that has historically adorned the top of urban buildings, the Marine Building steps back as it reaches skyward until it is topped by a humble sea-green pyramid. Approaching the building, a group of trees delimit my view of the tower above and redirect my gaze down toward the arched entrance, where two wooden doors framed in glittering polished brass are intricately engraved with detail akin to a Fabergé egg. The Marine Building is a paragon of Art Deco architecture. Completed four years after Stanley Park, the Marine Building is embellished with the spirit of nature, engraved with depictions of a fantastic marine world full of seahorses, starfish, crustaceans, and waving forests of seaweed.

This glamorous building's completion in 1930 unfortunately coincided with the chilling realities of the Great Depression. While the city was on hard times, the Depression also forced a break in the previous frenzy of industry and demanded a re-evaluation of Vancouver's destiny. The newly completed building stood in cold contrast to Vancouver's then-necessary frugality, but it also inspired the city and gave it the courage to face a new future.

In 1956, the brass and terracotta marine world depicted on the Marine Building became reality: that is when the Vancouver Aquarium opened in Stanley Park.

LEFT 71. Some of the marine animals on display at the Vancouver Aquarium, officially Canada's first public aquarium.

BOTTOM MIDDLE 72. The base of the Marine Building is marked by an ornate arched entryway.

BOTTOM RIGHT 73. Motifs are intricately carved onto the entryway. While most of the carvings relate to the marine world, there are depictions of other aspects of Vancouver's natural sceneries.

THE VANDUSEN, BLOEDEL AND THE BEATY

The sky was cloudless and my morning at the VanDusen Botanical Garden was hot and drowsy. Even beneath a sheltering oak tree, my skin practically steamed from the humid air. Yet at its partner facility, the Bloedel Conservatory, the air was refreshingly cool: the sun's heat was muted by the plexiglass cells of the domed roof and air-conditioning blasted at full power. Sharp blades of palm trees cast dark blue shadows onto the green sedge grass while exotic plants that would never endure Vancouver's climate thrived. With a brush in hand, I watched colourful pheasants fly above the foliage. Unlike the cabinet of curiosities full of taxidermies at the Beaty Biodiversity Museum, this conservatory imported the living tropical idyll to the modern metropolis, reaffirming Vancouver's affection for nature.

74. The undulating petals that form the visitor centre at the VanDusen Botanical Garden are actually the green roofs.

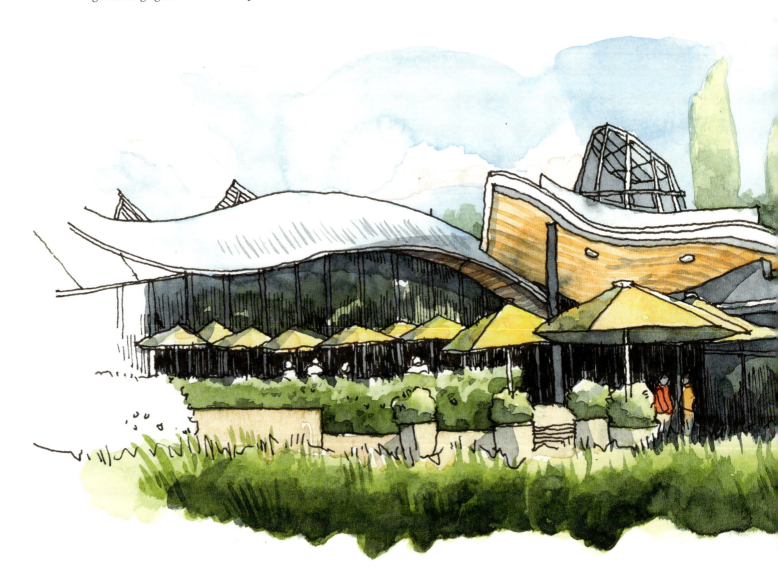

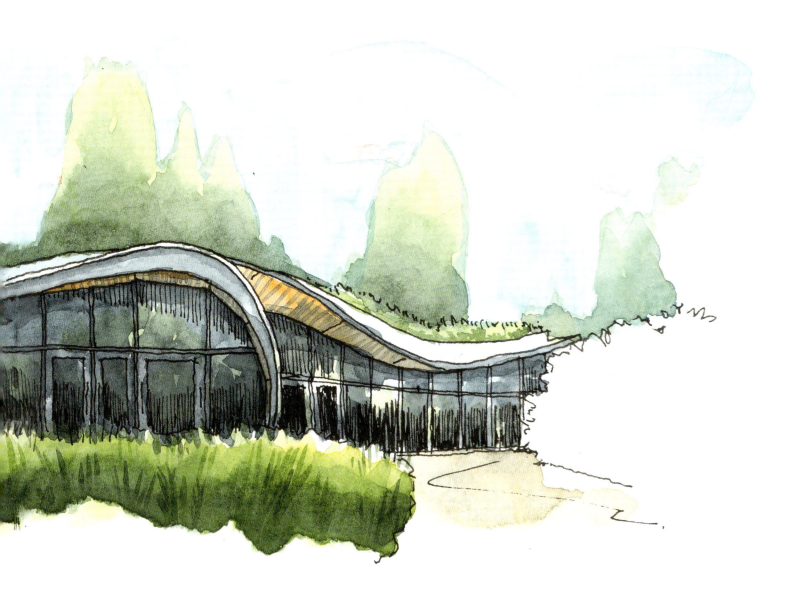

75. Three out of more than 7,500 plant species and varieties that can be found at the VanDusen Botanical Garden.

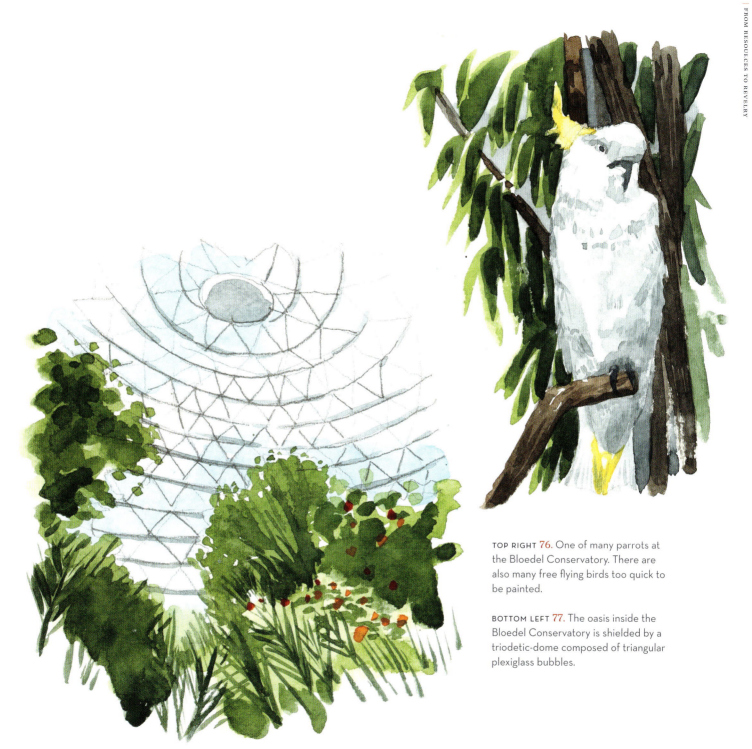

TOP RIGHT 76. One of many parrots at the Bloedel Conservatory. There are also many free flying birds too quick to be painted.

BOTTOM LEFT 77. The oasis inside the Bloedel Conservatory is shielded by a triodetic-dome composed of triangular plexiglass bubbles.

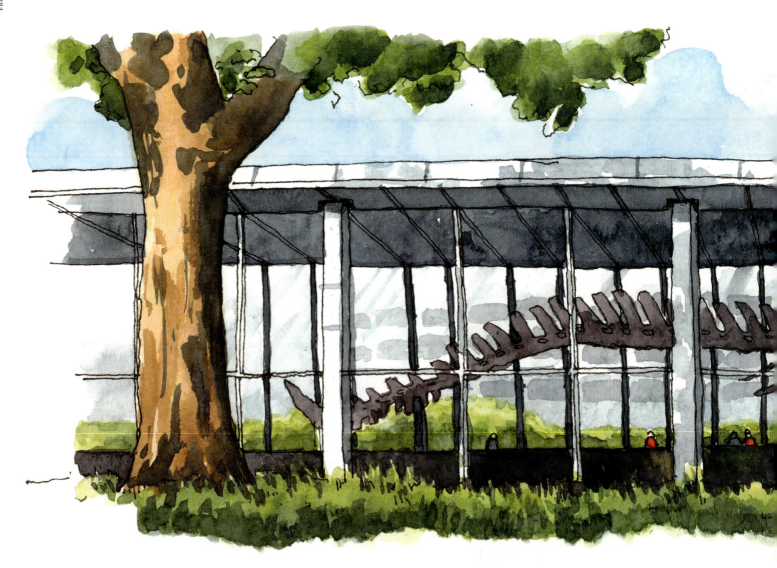

78. Skeleton of a Blue Whale calls attention to the Beaty Biodiversity Museum and invites pedestrians into the subterranean museum. Located cross-town on the UBC campus, the Beaty is another stellar tribute to Vancouver's natural heritage.

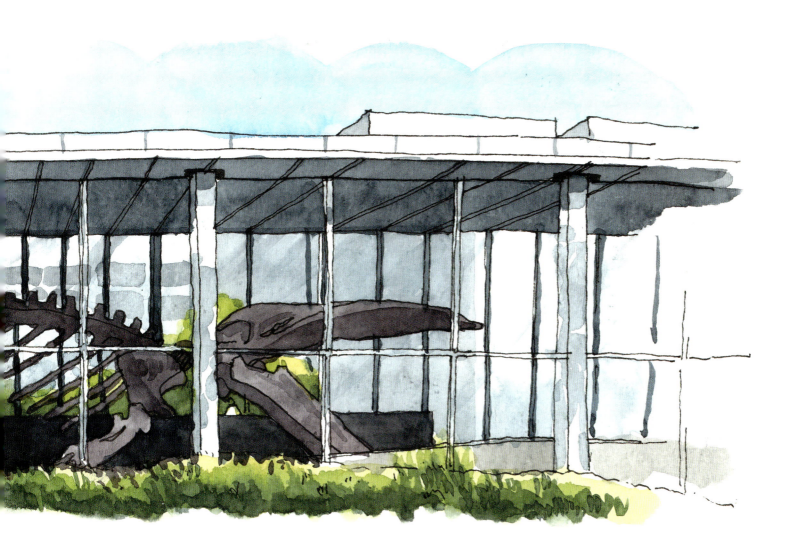

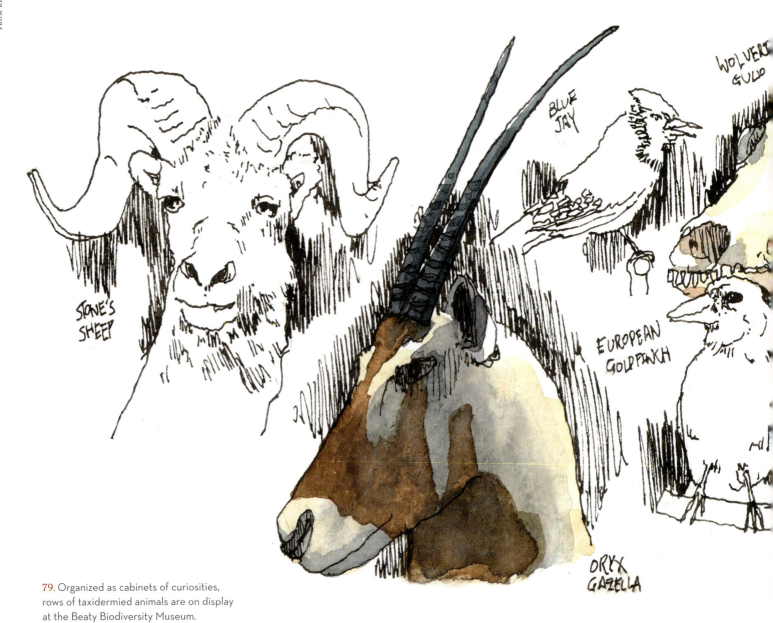

79. Organized as cabinets of curiosities, rows of taxidermied animals are on display at the Beaty Biodiversity Museum.

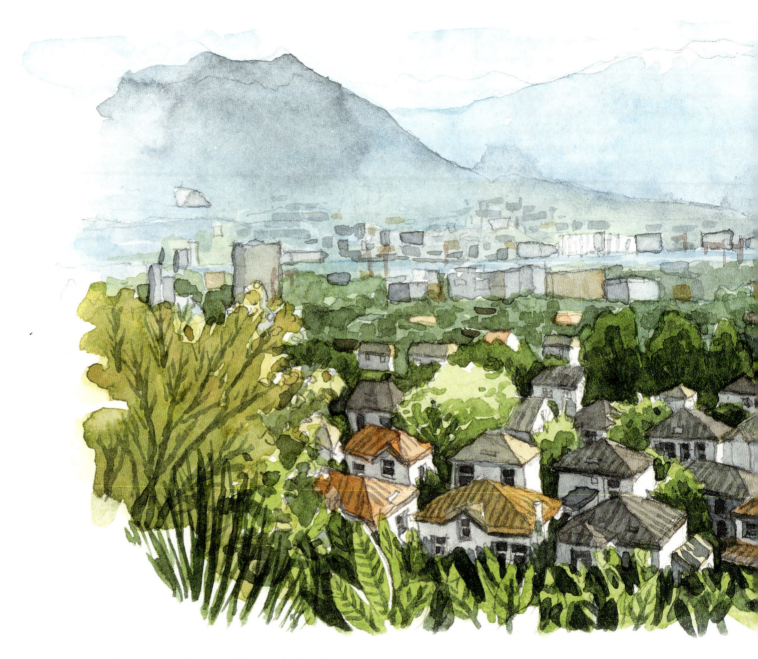

80. These houses are in high-demand. Not only do they offer generous space for a family, the neighbourhood is close to downtown yet free of the hustle-bustle.

Perched on the top of Vancouver's tallest hill, ironically named Little Mountain, the trails surrounding the Bloedel Conservatory offer sweeping views out over the city. Rows of single-family houses emerge against the ravishing natural setting. The houses, almost identical in size and geometry, are sandwiched between generous lawns. While this is not the suburbs, Ebenezer Howard's Garden City Movement did find its place in Vancouver in the early 1960s, when the city sprawled across the Lower Mainland. The Garden City Movement's desire for "beauty of nature ... fields and parks of easy access ... bright homes and gardens" aligned with Vancouver's deep-seated fascination with nature.[ix] At the same time, just like in other garden cities, Vancouver became dependent on the automobile.

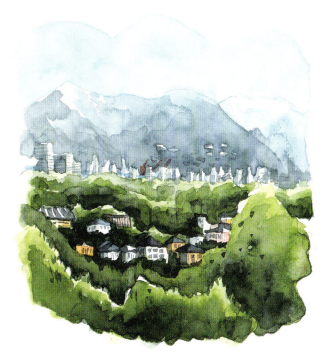

81. Trails beside the Bloedel Conservatory offer views over rows of single-family houses framed against the sublime mountains in the distance.

TWIN VIADUCTS

Perhaps the clearest manifestation of Vancouver's dependency on the automobile is the Dunsmuir and Georgia viaducts, a pair of elevated freeways that sweep above the southern edge of Chinatown. From the city centre, the three-lane West Georgia and Dunsmuir streets connect seamlessly to the viaducts, where the surrounding buildings recede and an expansive view of False Creek bids farewell to each rushing car.

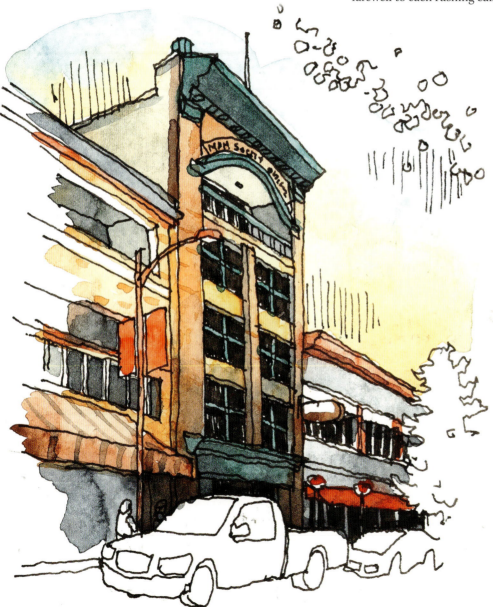

BOTTOM LEFT
82. The Man Society building, an example of hybrid Chinese-Western architecture in Chinatown might have been torn down if the freeway plan was fulfilled.

BOTTOM RIGHT
83. The ruthlessness of West Georgia and Dunsmuir viaducts stand in cold contrast to the cultural richness of Chinatown.

Instead of a freeway to far-away destinations, the viaducts end abruptly at a tree-lined neighbourhood street just a two-minute drive away. Originally planned to connect downtown to the mushrooming suburbs and the Trans-Canada Highway, the viaducts would have rammed through the historic fabric of Chinatown. But by the time the first portion of the viaduct was completed in 1972, Vancouver had changed: the Seawall in Stanley Park had opened, Greenpeace was founded, and Chinatown had become a designated historic district. Vancouver's new relationship with nature came to the forefront and anti-freeway sentiment spread across Vancouver. In the end, a new government came in and the freeway project was abandoned for a more scenic future.

Almost half a century after completion, the Dunsmuir and Georgia viaducts are now destined for destruction. The city that once came close to building an LA-style cloverleaf interchange now prides itself as the only major North American city without an inner-city freeway. To be sure, more evidence on Vancouver's dramatic shift from resources to revelry.

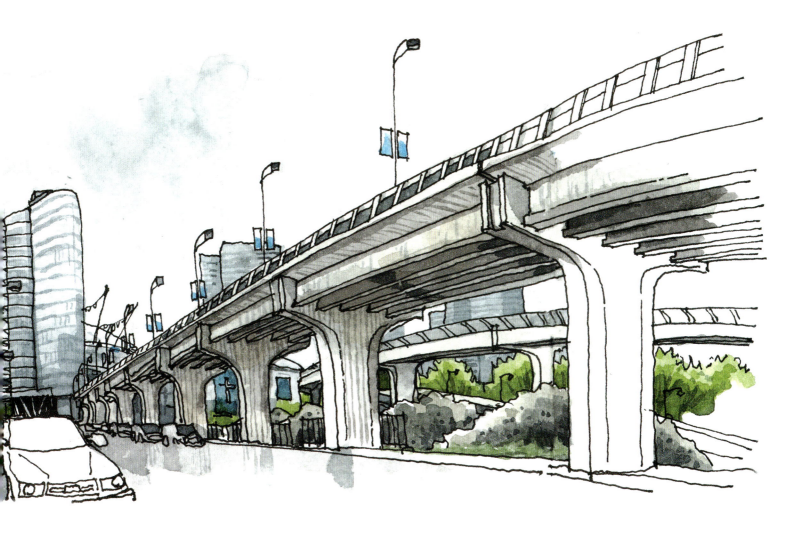

THE ROAD LESS TRAVELLED

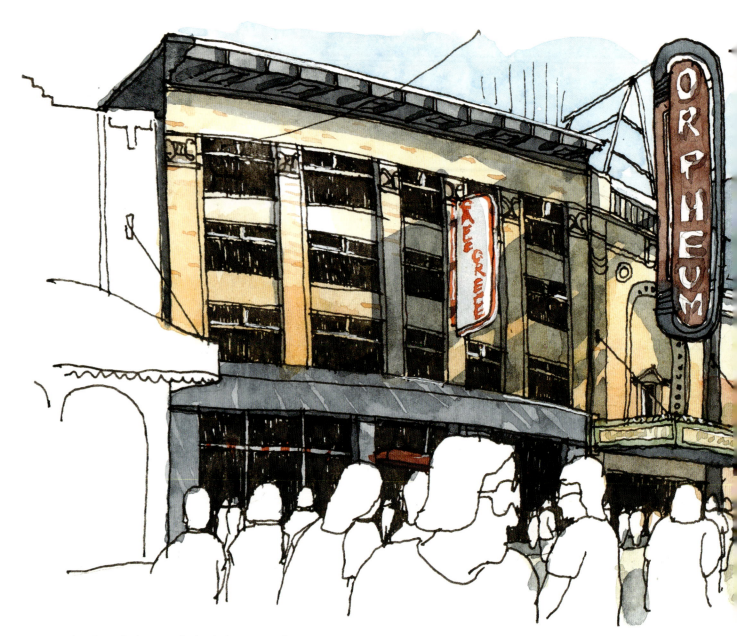

84. Not only is Granville Street packed with shoppers on the weekend, it is also known as Vancouver's "Theatre Row." The Orpheum, opened as a vaudeville house in 1927, was once the biggest theatre in Canada.

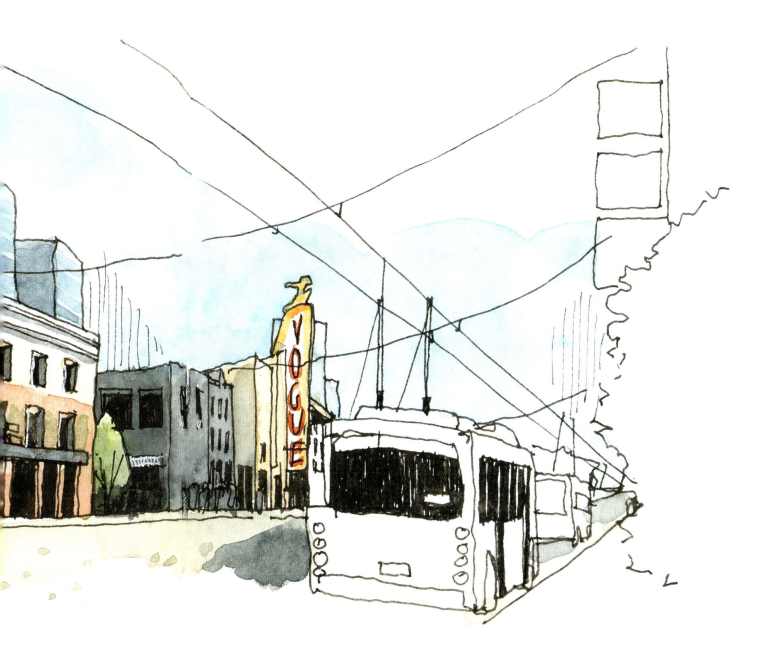

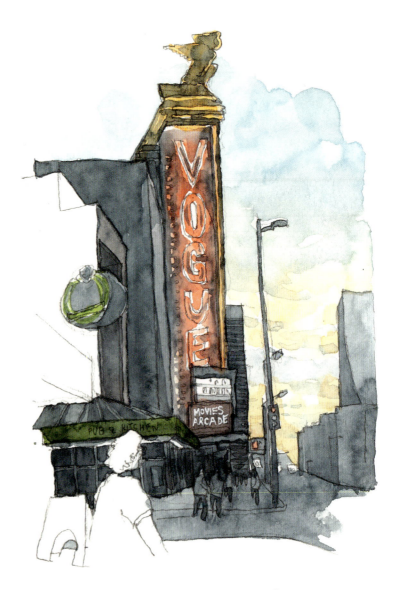

85. Following the decline in vaudeville's popularity, the Orpheum was transformed into a movie theatre while new movie houses like the Vogue Theatre sprung up.

86. At night, vast arrays of neon signs enliven Granville Street. From the 1930s to the 1960s, neon signages were part of Vancouver's urban identity and Granville Street was known as "The Great White Way."

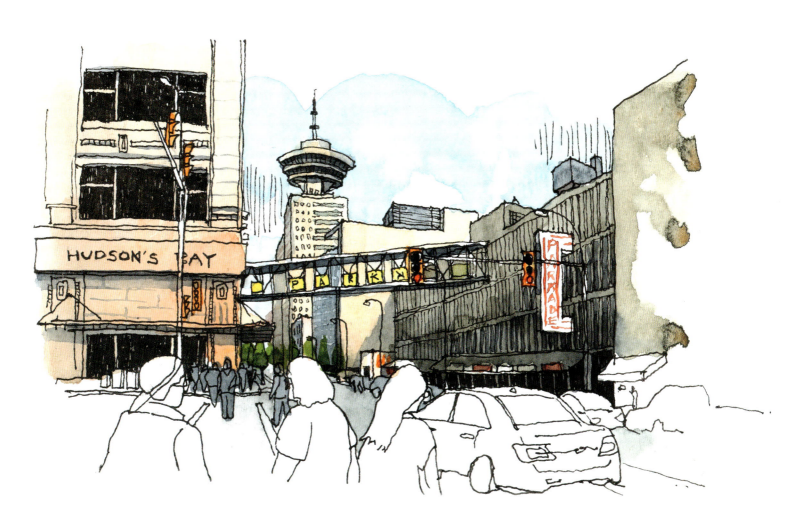

87. The streets surrounding the cream terra cotta Hudson's Bay building are bustling with shoppers during the weekend and office workers during the week.

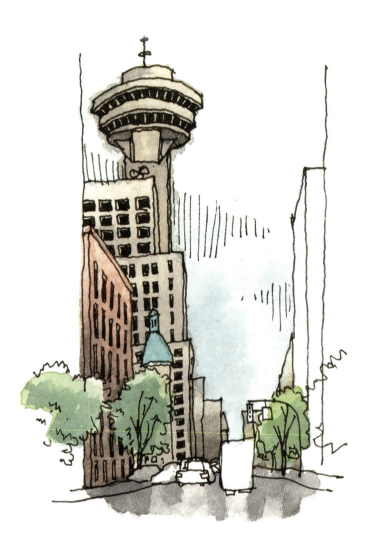

88. One of the most distinctive landmarks in Vancouver's skyline is Harbour Centre, with its lookout tower and its revolving restaurant.

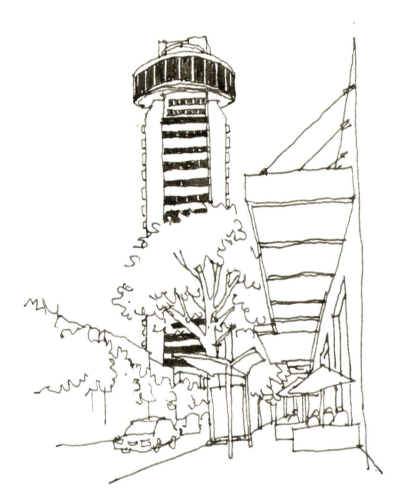

89. Another revolving restaurant was at the Empire Landmark Hotel in the West End. The hotel was demolished in 2018.

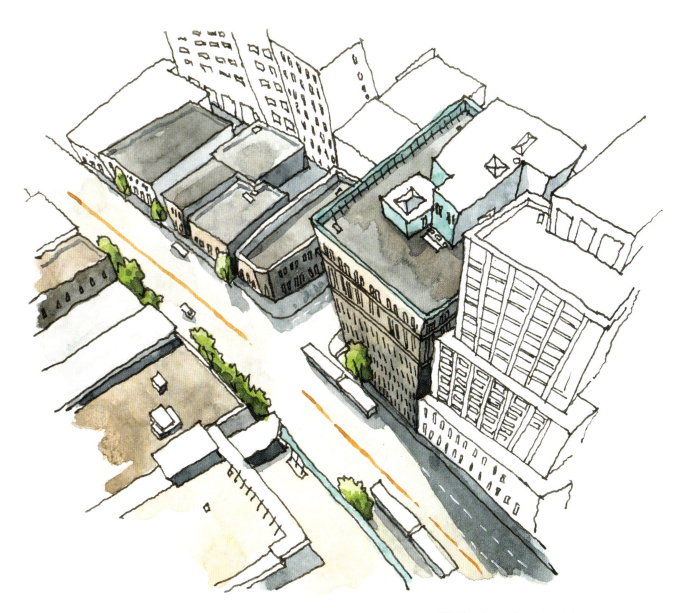

90. The observation deck of the Harbour Centre Lookout offers visitors a panoramic inspection of the city below.

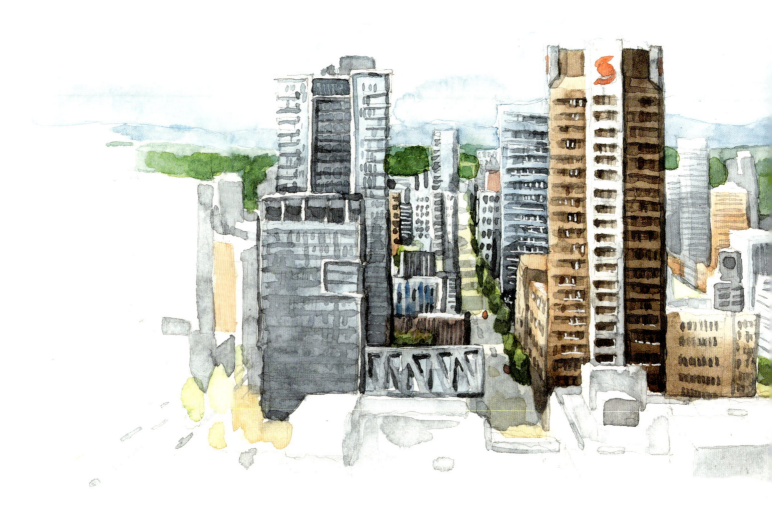

LEFT 91. The observation deck offers new perspectives on the skyscrapers that dominate the city centre. On the left is the Telus Garden, completed in 2015, and on the right is the Scotia Tower completed in 1977.

RIGHT 92. The white and brown Scotia Tower is one of the most distinctive office towers in Vancouver's skyline. When the Seymour Building was completed in 1920, the granite-faced office tower was at that time one of the most distinctive buildings in the city.

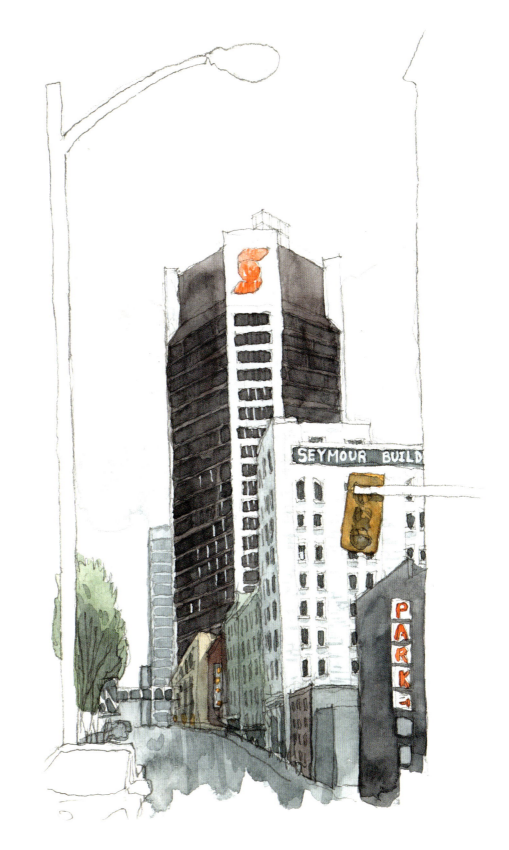

ROBSON SQUARE

The rainy morning has brought an end to the heat spell and like dry grass that has turned lush again, Robson Square has burst into life. Spread over three city blocks, the square is crowded with those wishing to see and be seen, but it is also Vancouver's civic centre. Gentle changes in topography interlace the public spaces with other sites: the main square is flush with Robson Street and the Vancouver Art Gallery; a subterranean skating rink is sunk beside the entrance to UBC; and a quiet garden lines the elevated walkways to the Law Courts. Thin concrete steps delineate the shifting topography and etch horizontal lines across the development. Surrounded by skyscrapers at the geographical centre of downtown, Robson Square's embrace of horizontality, prioritization of the eyeline over the skyline, seems almost obstinate.

However, things could have turned out very differently. The original plan was to place a 208-metre-tall tower here as a "corporate monument." It was only with the success of the anti-freeway movement and a change of provincial government that the tides turned. Citing the "fear of the dark shadow" as a reason against the proposed skyscraper, a redesign of B.C. Place was commissioned and the final design by Arthur Erikson put the original B.C Centre "on its back": the new design replaced the vertical lines with horizontal lines thereby turning a corporate monument into an anti-corporate monument. Vancouver was certainly not going to follow other cosmopolitan cities.

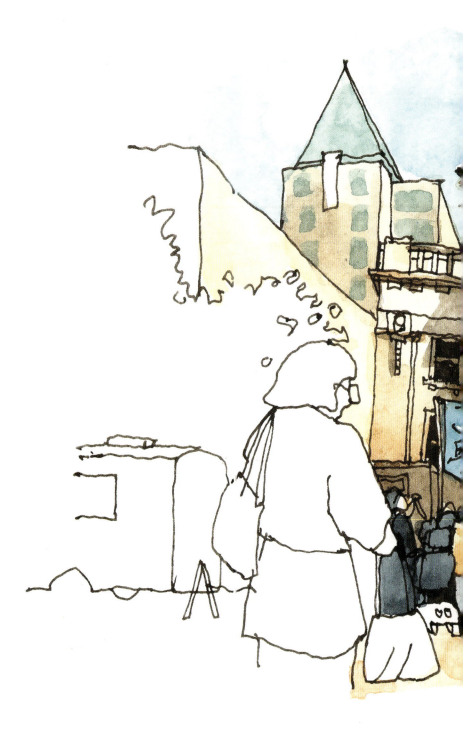

93. As a civic space, Robson Square is a regular gathering space for protests and demonstrations.

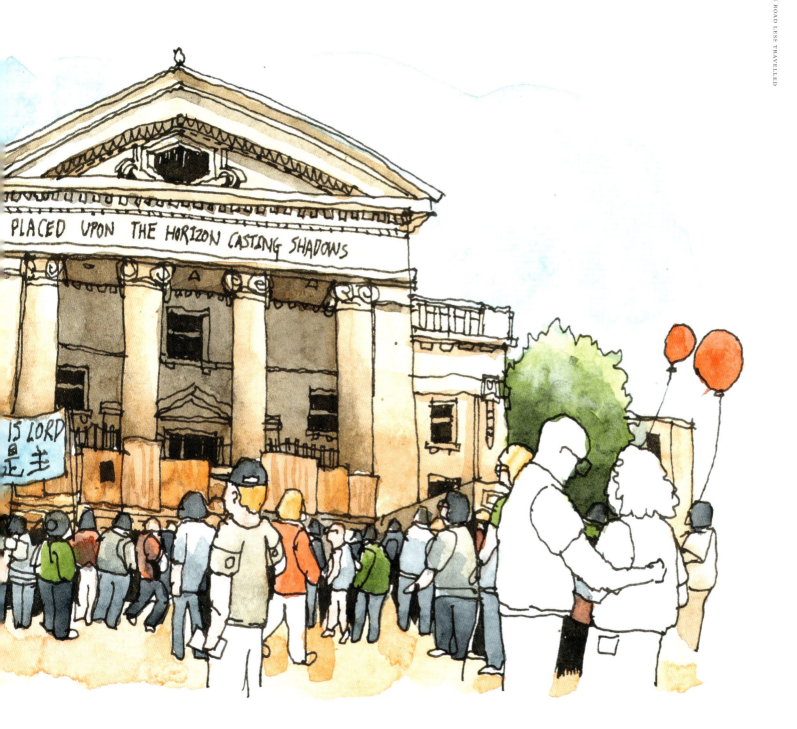

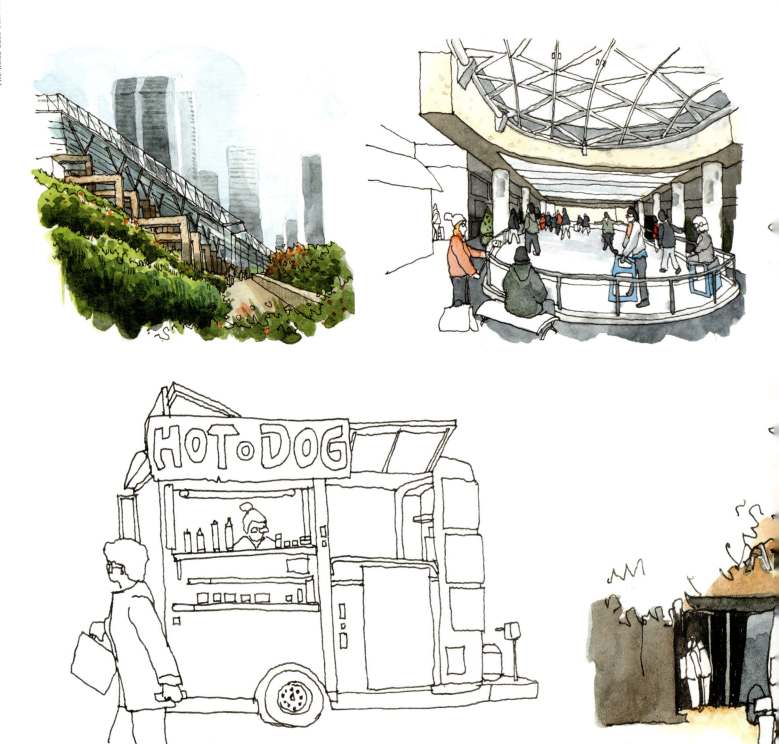

TOP LEFT 94. The garden on the elevated walkway connecting Robson Square to the Law Courts is designed by Cornelia Oberlander, the same landscape architect Erikson worked with for the Museum of Anthropology.

TOP RIGHT 95. Underneath the square is a skating rink. In summer, the rink is a popular place for dance crews to practice.

BOTTOM LEFT 96. Several food trucks can typically be found along the edges of the square, offering pedestrians an opportunity for a quick bite.

BOTTOM RIGHT 97. Vancouver Art Gallery is housed in the former main courthouse of the city.

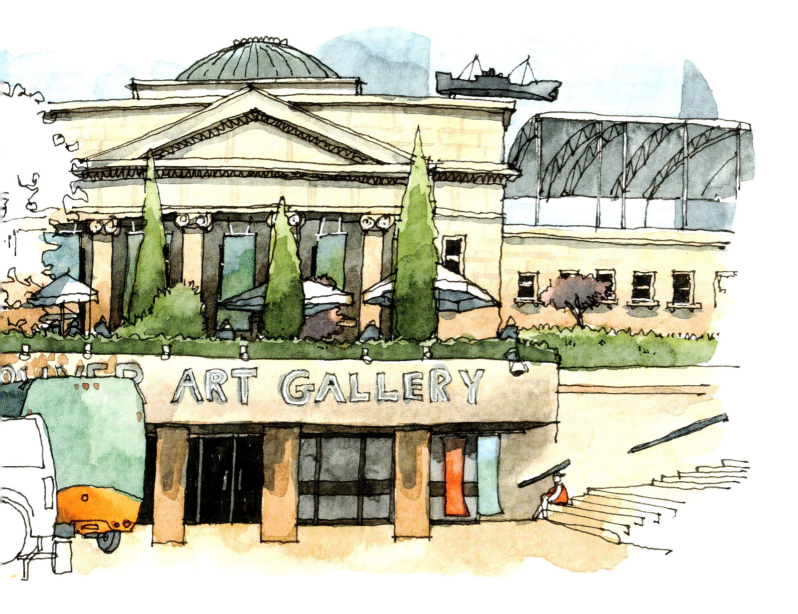

ENGLISH BAY

Robson Street extends out of Robson Square, where large crowds of shoppers wave colourful bouquets of shopping bags. Farther north at its intersection with Denman Street, the view opens toward False Creek, luring pedestrians to English Bay where the Seawall reappears and runs between a strip of glistening sand and a row of formidable concrete tenements. Unlike the trail around Stanley Park that enhanced appreciation of land and sea, this segment of the Seawall mediates the interface between the city and the sea.

Along this portion of the Seawall, the passion for fitness hereabouts is most obvious. While tourists walk along the trail at leisure, slowly taking in their surroundings, cyclists, rollerbladers, and joggers zoom by without care. Many of them wear little clothing, exposing their bodies in a glorious display of fitness that compliments Vancouver's pictorial identity. For many, the Seawall is a treadmill, a space for the acquisition and maintenance of body beauty.

TOP 98. Built in 1958 during the boom era of high-rise construction, the colourful Berkley Tower in the West End reflects the vibrancy of the neighbourhood.

RIGHT 99. The Inukshuk standing at an outcrop between English Bay and Sunset Beach was originally part of the Northwest Territories Pavilion during Expo 86. In 2010, the Inukshuk became the symbol of Vancouver's Winter Olympics.

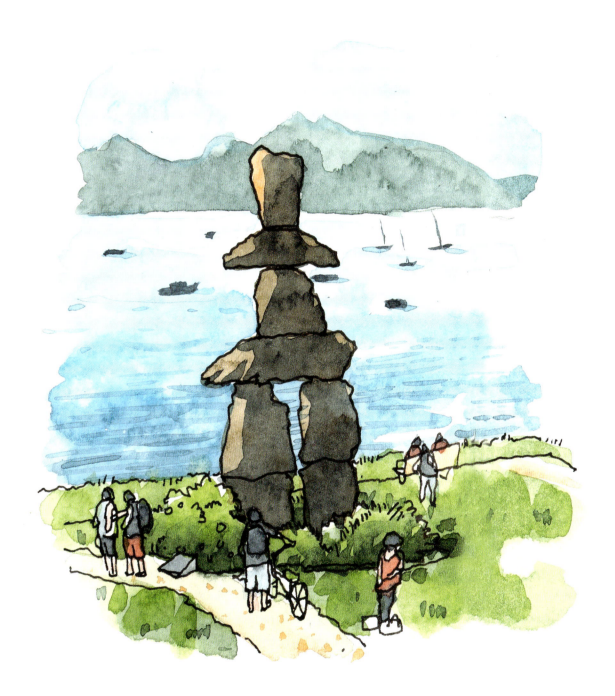

TOP LEFT 100. Beach-goers lean against the logs on Sunset Beach. These logs were originally part of the lumber industry until they were lost at sea and washed ashore.

TOP MIDDLE 101. The shadow of the same couple lengthens as the sun sets. Just as its name suggests, Sunset Beach is one of the best places to watch the sunset in Vancouver.

TOP RIGHT 102. A street crossing in Davie Village—often referred to as Gay Village—is painted in the colours of the pride flag. The area is home to Western Canada's largest LGBTQ+ community.

BOTTOM LEFT 103. At the end of a work day, English Bay Beach is packed with locals lounging on the field. A wide range of activities take place: sunbathing, reading, sleeping, chatting, writing—in many ways, this beach is the West End's living room.

BOTTOM MIDDLE 104. One of many restaurants lining Denman Street.

BOTTOM RIGHT 105. A lifeguard stand on Sunset Beach.

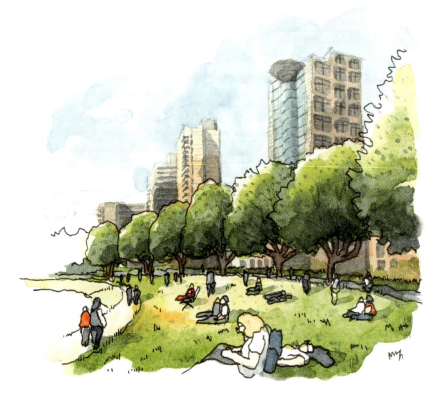

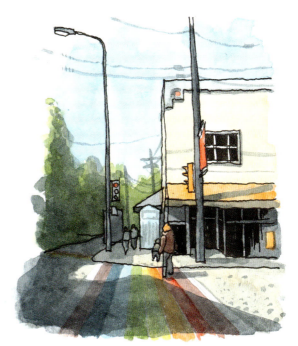

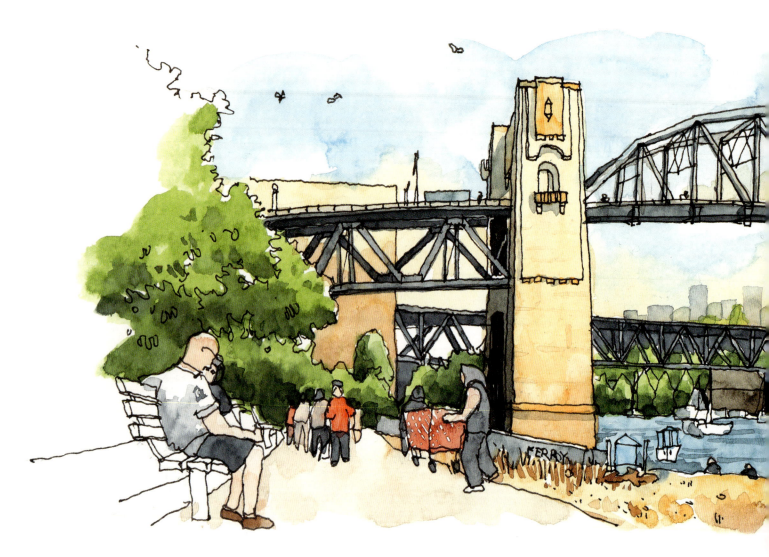

106. From Sunset Beach, Burrard Bridge acts as a gateway to Vancouver's inner harbour.

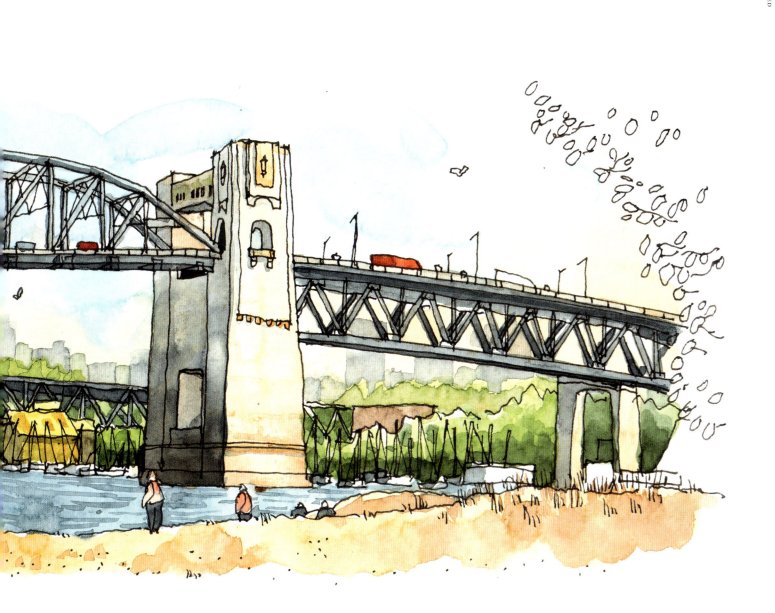

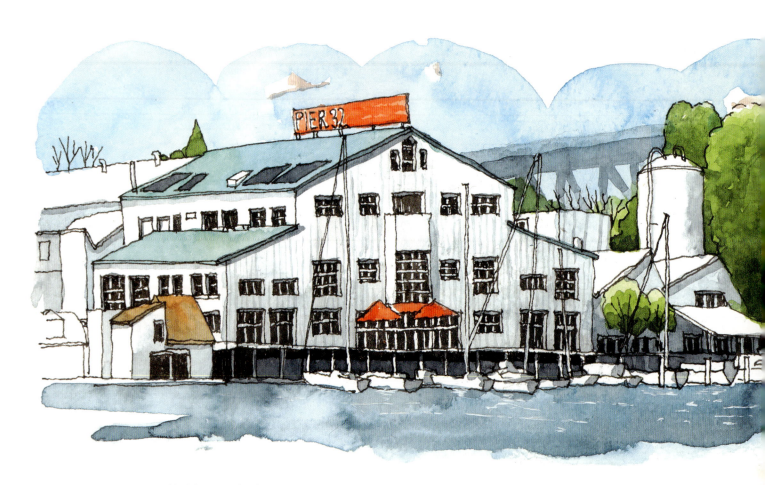

107. Granville Island's industrial buildings are clearly visible from North False Creek. The steel trusses of Granville Bridge can be seen in the distance.

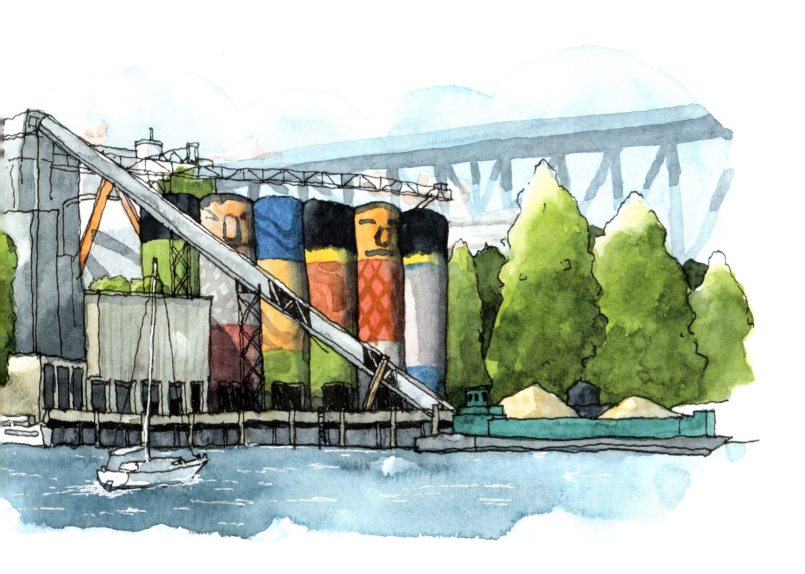

GRANVILLE ISLAND

False Creek is visible from English Bay, with Burrard Bridge dwarfing its surroundings. The bridge's presence is accentuated not by its span but by the thick pair of concrete towers that form a monumental gateway to the city's inner harbour. Delimited by the bridge's cold steel girders, a cargo ship carrying two piles of sand sits silently beside the warehouses, mills, and factories of Granville Island. While these structures reflect the human-made island's industrial heritage, they have been given a new and more emphatic life. Concrete silos are painted colourfully into caricatures, a warehouse is accented by red patio umbrellas, and a factory is painted in a yellow so radiant that it remains vibrant even on this uncharacteristically drab summer day.

RIGHT 108. These ferries carry tourists from North False Creek to Granville Island, but the "island" is also accessible from the Seawall trail.

FAR RIGHT 109. A yellow crane stands above a row of boathouses. On Canada Day, a large flag is hung beneath the crane's arm.

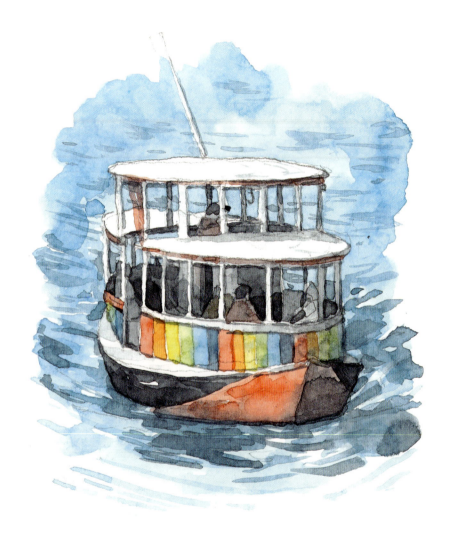

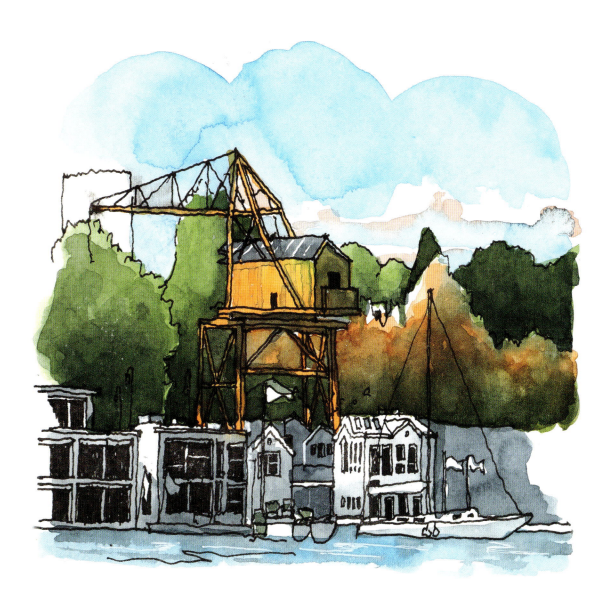

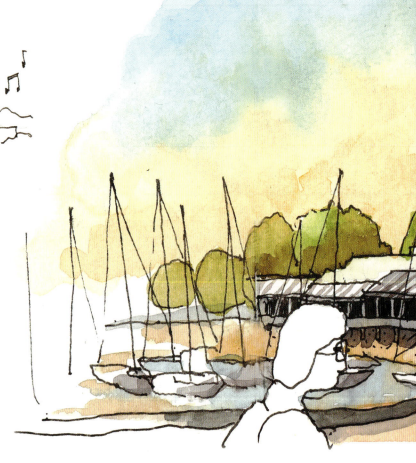

TOP 110. A decommissioned fishing boat underneath the Granville Bridge stands as a reminder of the First Nations who fished the waters around this island.

RIGHT 111. The amber glow of the setting sun creeps under Granville Bridge, bringing a romantic tinge of purple to the concrete structure. A red neon sign declares this as the main entrance to Granville Island.

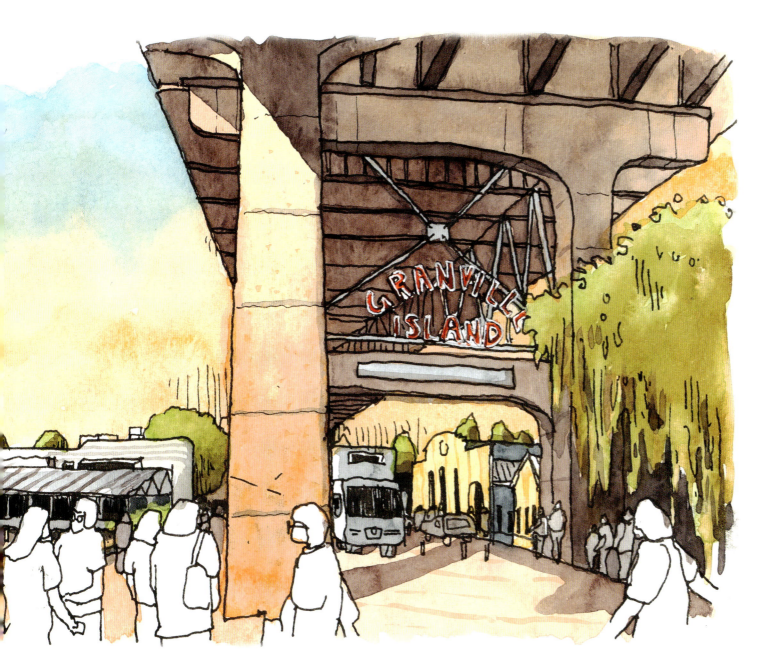

TOP 112. As the forces of industry weakened after WWII, warehouses were left to deteriorate. The revitalization of Granville Island involved giving these structures a new and more emphatic life.

BOTTOM 113. The Kids' Market on Granville Island is housed in a century-old factory painted in a yellow so radiant that it remains un-dampened, even on an uncharacteristically grey summer day.

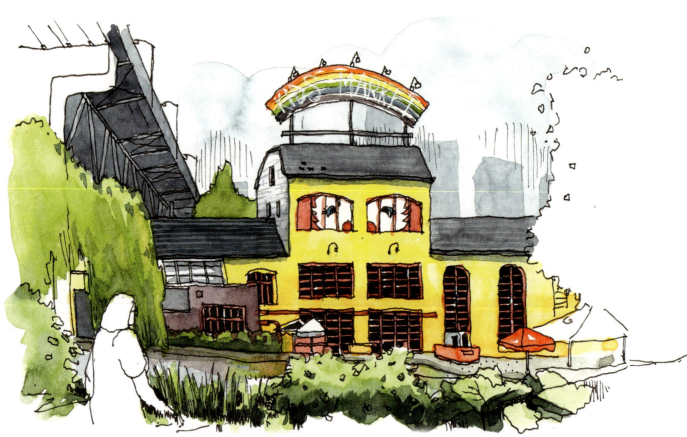

In retrospect, my first art classes were taken on Granville Island when I was four. My grandmother would take my cousins and me here each Wednesday morning. It may be possible that Vancouver has silently shaped my understanding of art for the last two decades. While many art galleries, studios, and an art school now occupy the sprightly corrugated-tin and concrete structures on the island, it was the Emily Carr University of Art and Design that first initiated change when it moved here in 1980. Not only has Vancouver's industrial history been overlaid by recreational facilities, it has also become enriched by art. Granville Island is a miracle where even industry has become picturesque and an embraced part of Vancouver's identity.

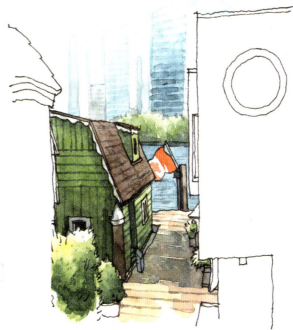

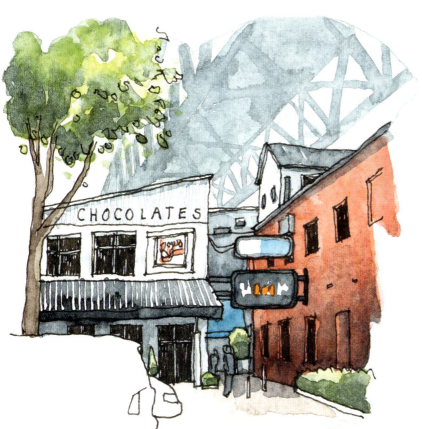

TOP 114. The structures on Granville Island are dwarfed by the steel truss of the Granville Bridge that looms overhead.

BOTTOM 115. Sea Village occupies the coast of Granville Island with several colourful boathouses.

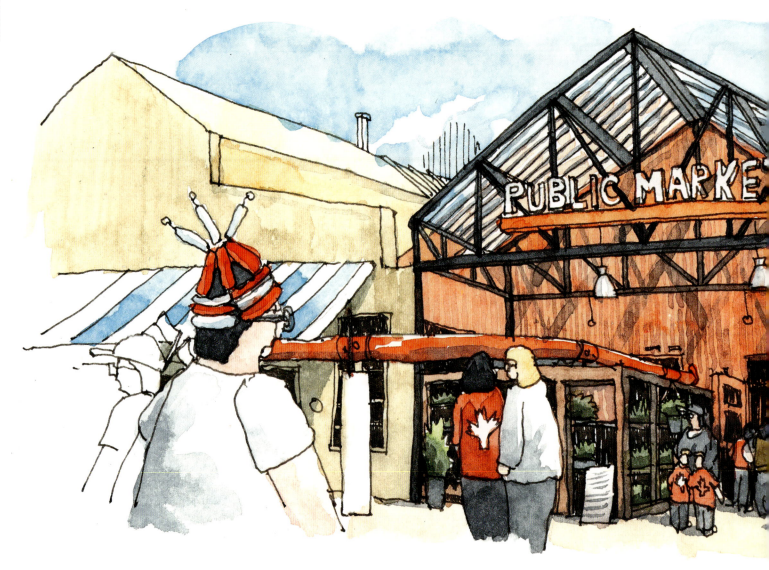

LEFT 116. On Canada Day, the streets surrounding the Public Market, the centrepiece of Granville Island, are spectacularly festive with everyone dressed up for the occasion.

TOP RIGHT 117. The Spanish Steps of Vancouver: on the other side of the Public Market, row upon row of people sit—gelatos in hand—on steps facing the bay.

BOTTOM RIGHT 118. The concrete and exposed steel structure that once housed Emily Carr Art and Design University, resonates with the surrounding's industrial history. Although the university moved out of Granville Island in 2017, the neighbourhood continues to be a hub for artists.

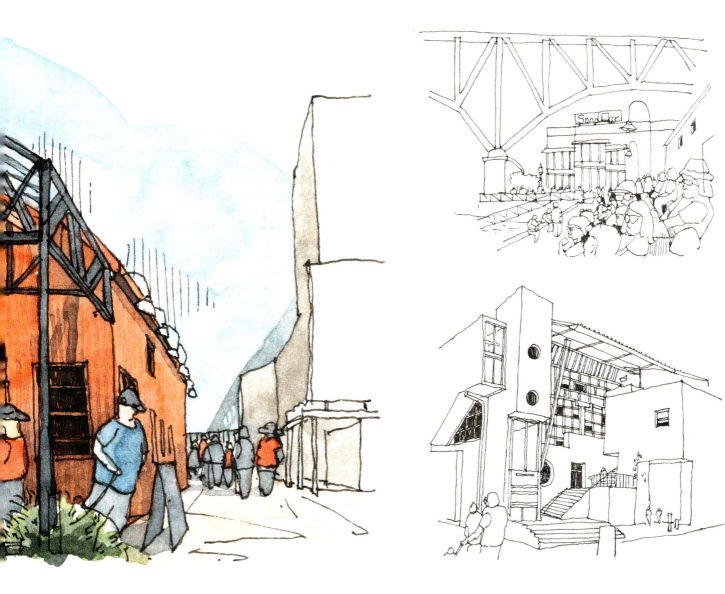

PICTURE PERFECT

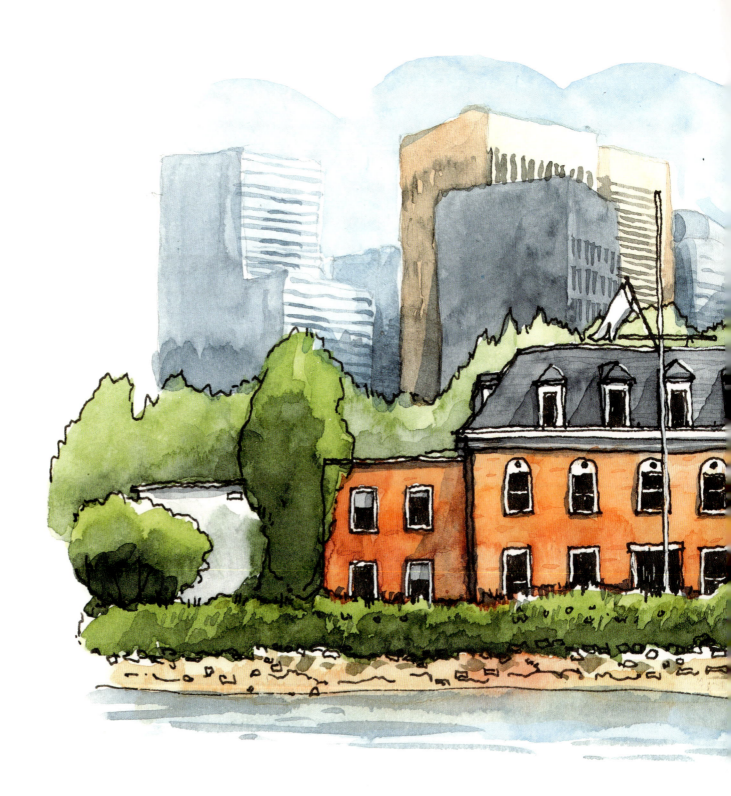

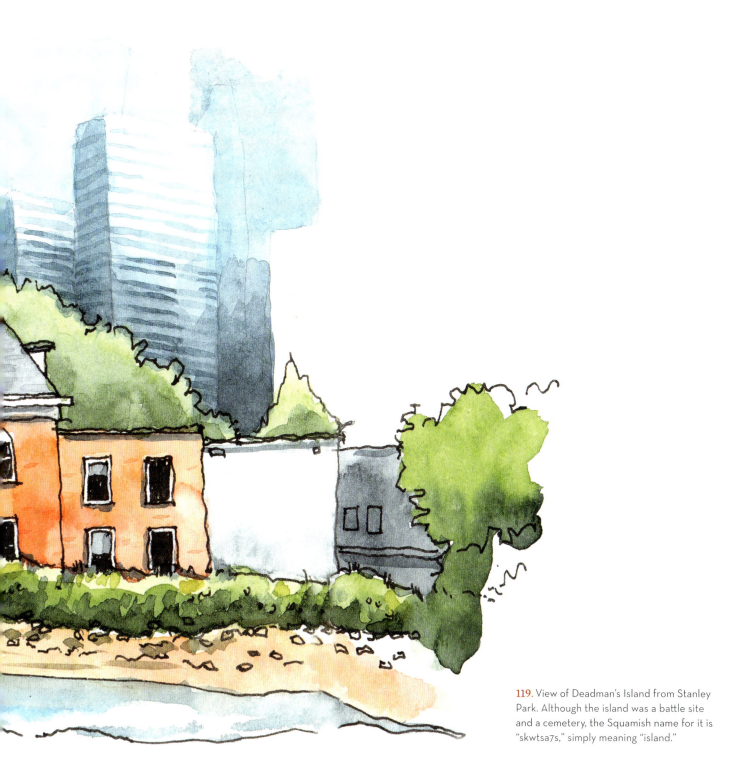

119. View of Deadman's Island from Stanley Park. Although the island was a battle site and a cemetery, the Squamish name for it is "skwtsa7s," simply meaning "island."

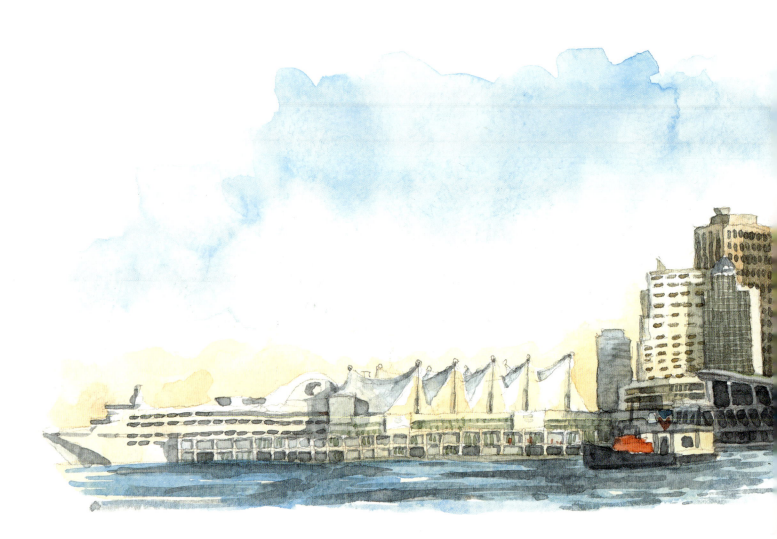

120. The skyline of Vancouver from Stanley Park's Seawall. Canada Place's five towering sails contrast with the low-lying form and green roof of the Vancouver Convention Centre.

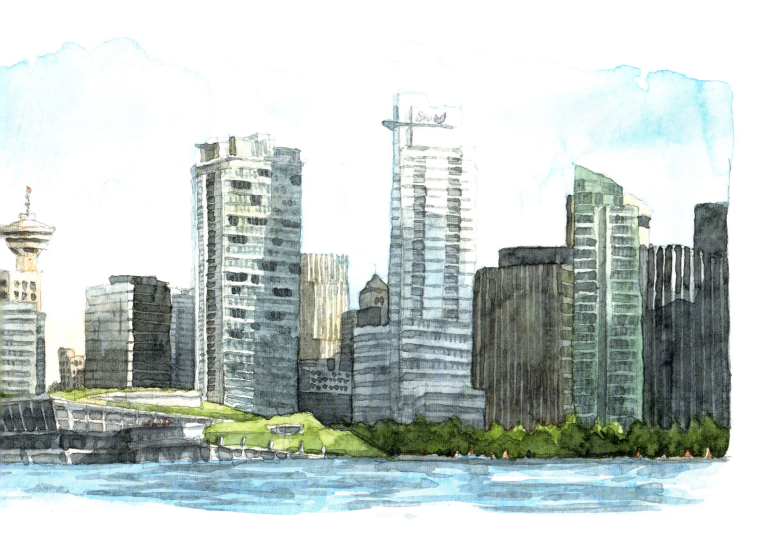

CANADA PLACE

The city's high latitude blesses the region with long summer days and it is only at nine that the sky blushes toward the west. Along the Seawall, large crowds gather with rows of cameras mounted on tripods in anticipation of fireworks that will signal an end to the Canada Day celebrations. With sketchbook in hand, I sit down on the edge of the Seawall, allowing my feet to hang freely above the lapping Pacific waves, and begin plotting the skyline onto the page.

Out over the bay, the peninsula once entirely covered by groves of trees has been replaced by a soaring metropolis. As the sky darkens, patches of glass on the condominium towers light up against the dimming sky, their inhabitants eager to watch the fireworks. One building stands out emblematically against the rest. Anchored on the harbour beside Alaska-bound cruise ships, Canada Place looks like an oversized luxury liner with a majestic roofline of five towering sails. I have looked at it many times from this very spot and each time, its sails inspired a desire to escape to sea. But the setting sun has the ability to stir up otherwise forgotten thoughts. As I watch the gentle ebb and flow of the ocean against the five motionless sails, I cannot help but focus on the structure's shackled reality. Even with sails, any attempt for Canada Place to escape the city is futile: the architects have firmly bound it to land, fixing it eternally to shore.

121. A cruise ship is dwarfed by the enormous scale of Canada Place.

TOP MIDDLE
122. Seaplanes docked beside the Vancouver Convention Centre carry locals and tourists to different parts of B.C. and Seattle.

BOTTOM RIGHT
123. The Vancouver Convention Centre does not resist the continuous plane of landscape along the Seawall. Instead the landscape is extended onto its green roof.

Perhaps Canada Place is more of a shored Noah's Ark, a vessel that once carried the Canada Pavilion for Vancouver's Expo 86. It was on this plot of land, in 1983, that Queen Elizabeth II started a concrete mixer and offered an "invitation to the world" to attend what is now widely considered to be one of the most important events in Vancouver's history. As the international beacon turned to Vancouver that year, Expo 86 served to embolden Vancouver's collective confidence, raised its identity onto the world stage, and catalyzed urban developments that completely revolutionized the city. At the same time, Vancouver began to decouple from British Columbia's historically resource-driven economy.

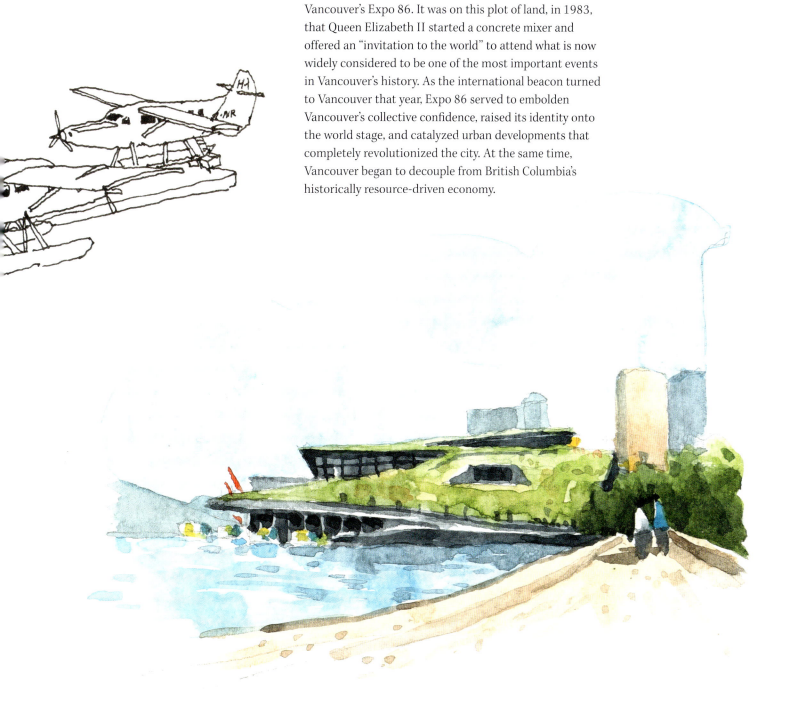

SKYTRAIN

Transportation has been intrinsically linked to milestones in Vancouver's development. In 1887, the completion of the transcontinental railroad turned the small townsite of Granville into the thriving metropolis of Vancouver; in 1972, the success of the anti-freeway movement shifted Vancouver and the peninsula toward a more beautiful urbanism. It seems only fitting that the Skytrain, first built for Expo 86 whose motto was "Transportation and Communication: World in Motion—World in Touch," was in itself a milestone in the city's history.

Unlike the subway system common to dense metropolises, Vancouver's Skytrain hovers above the city. The dark tunnels that characterize city commute is replaced by sunlight-filled cabins and postcard-ready views of the city. It is not uncommon to see tourists snap photos, while even the most habituated commuter will lift her head and silently take in the beauty.

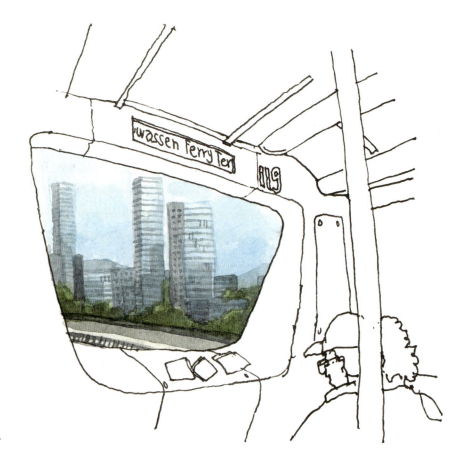

124. Skytrain's Canada Line does not have on-board operators. Instead of an operator's cab at the end of the train, a large pane of glass completes the panoramic vista.

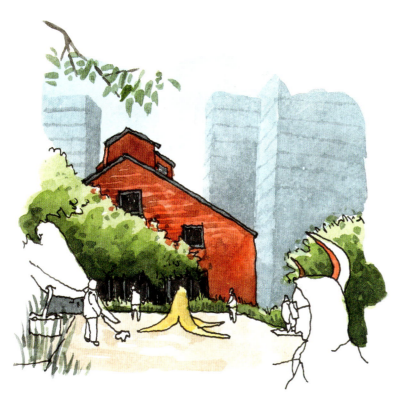

SCIENCE WORLD

A single cloud hangs above False Creek where Science World shimmers like a jewel. During Expo 86, this was part of the fairground where a plethora of colourfully themed pavilions dazzled the public. Today, only a few such structures remain. Science World is one of them. Standing beside it, the dome's faceted and mirror-like surfaces reinterpret snippets of the surrounding ocean, city, and mountains into an entrancing kaleidoscope of Vancouver scenes.

I have never been inside the dome of Science World, which houses the world's largest OMNIMAX theatre. But today my curiosity demanded satisfaction and the next screening was a documentary on space.

While the exterior of the dome reflects its surroundings, the interior is a hermetic sphere giving no reference whatsoever to the outside environment. When the lights dim, I find myself launching into the depths of space. For the next hour, Vancouver is light-years away and the projected images on the screen are my reality.

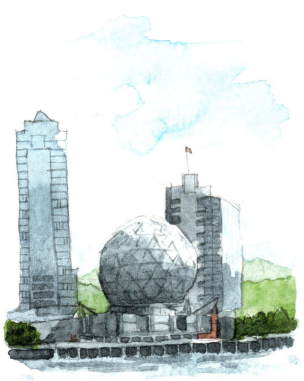

TOP 125. Prior to Expo 86, False Creek was home to dilapidated sawmills, steel fabrication plants, foundries and various other declining industries. The red salt house—now a beer market—in Olympic Village stands as a reminder of the neighbourhood's industrial past.

BOTTOM 126. Science World appears as a shining jewel from Cambie Street Bridge. In 2010, a massive grey whale was spotted in False Creek, travelling all the way to Science World before returning out to the ocean.

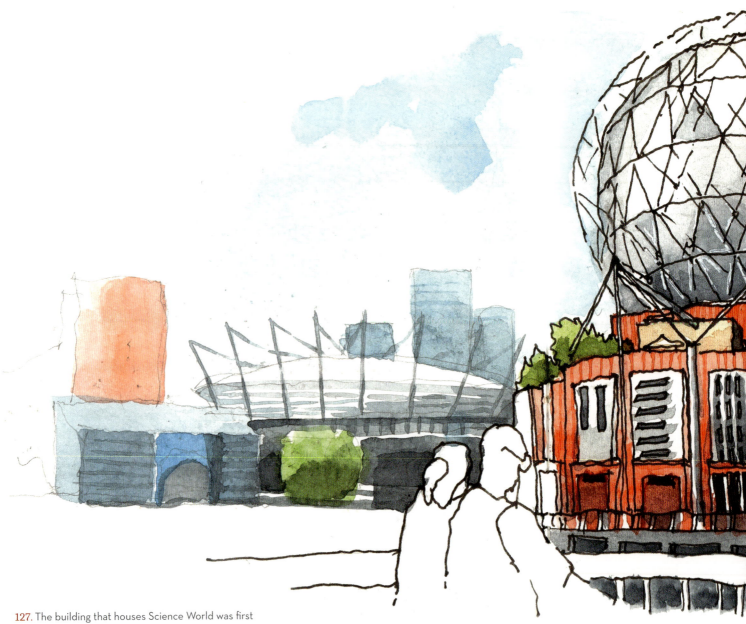

127. The building that houses Science World was first built in 1985 as the Expo Preview Centre. When Expo 86 opened, it was turned into the Expo Centre, the largest theme pavilion on the fairgrounds.

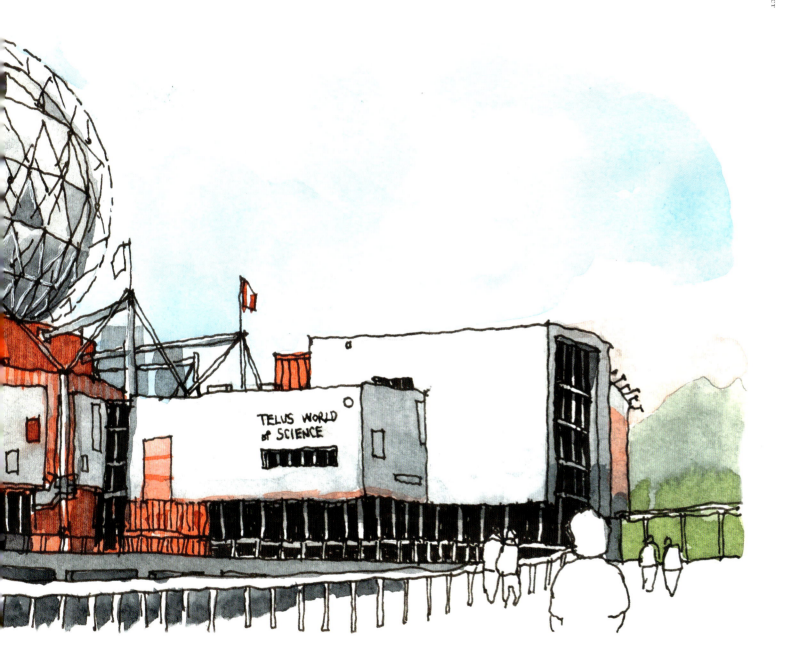

CHINESE GARDEN

China, in addition to building the largest national pavilion during Expo 86, made its mark on the city by creating a classical Chinese garden. My grandmother volunteers near the garden once a week and she has been asking me to draw the area ever since I landed in Vancouver.

White plaster walls mark the border between the tranquil Dr. Sun Yat-Sen Classical Chinese Garden and bustling Chinatown. On the other side of the circular entryway, capricious trees bend and branch off free from order. Underneath their irregular foliage, a serpentine river casually intersects with the meandering pathway where craggy rocks slice into turquoise water. The stillness of the water is only interrupted by turtles or the occasional group of koi. While the sort of order common in Western gardens appears absent, harmony nevertheless prevails here in the form of a naturalized beauty, an artful irregularity embraced by the aesthetics of *sharawadgi*, the Chinese concept of "beauty without order." With the completion of the Chinese Garden in Vancouver, the Chinese, who played a key role in the industrialization of Vancouver, have tapped into and expanded upon Vancouver's pictorial identity.

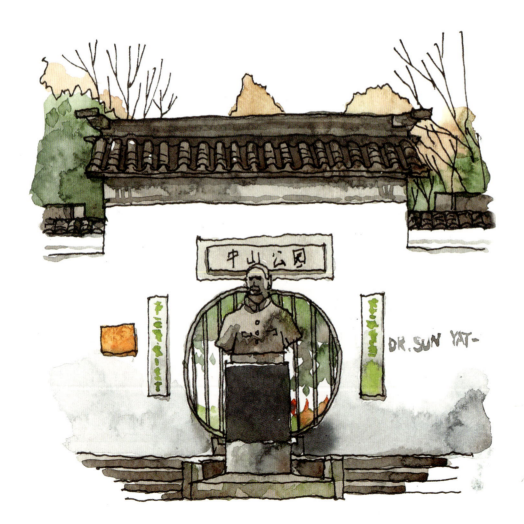

BOTTOM LEFT 128. The garden is named in honour of Dr. Sun Yat-Sen, considered the father of modern China. His bust is placed in front of the circular entryway into the garden.

BOTTOM RIGHT 129. Dr. Sun Yat-Sen Classical Chinese Garden, the first Chinese garden built outside of China, against a forest of glass towers.

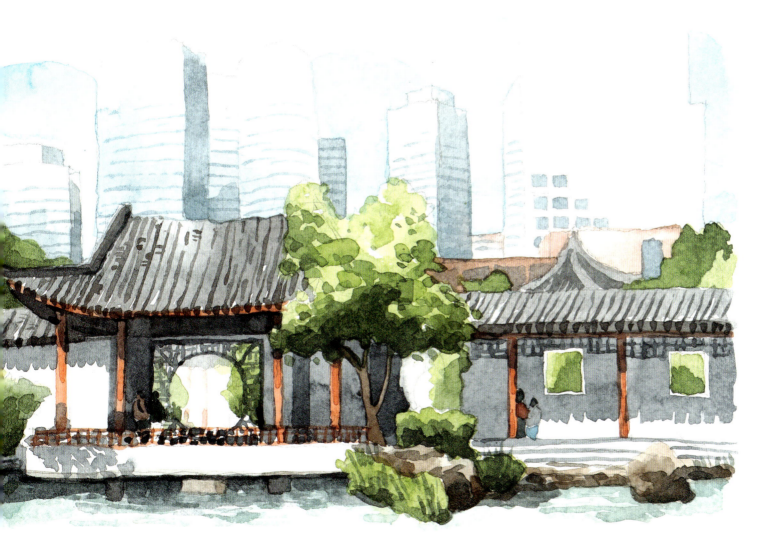

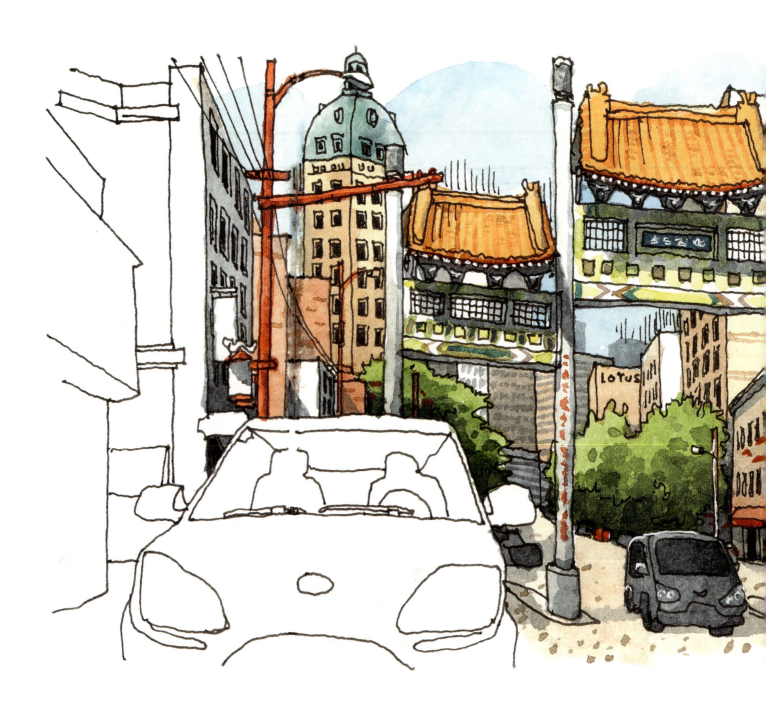

BOTTOM LEFT 130. Chinatown Millennium Gate over Pender Street was completed in 2002 as a way to market the district and improve business. The eastern face is inscribed with characters prompting onlookers to "remember the past and look forward to the future."

BOTTOM RIGHT 131. In the 1980s, Chinatown underwent "beautification" with the creation of bilingual street signs and the installation of ornate Chinese lamp posts.

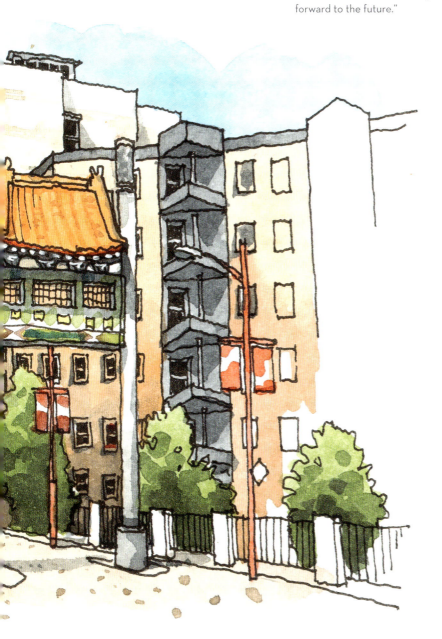

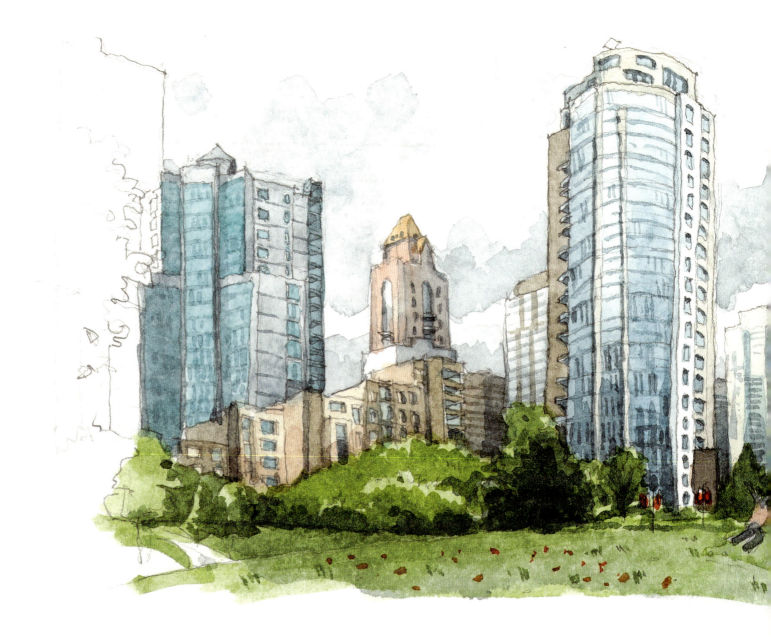

132. The Concord Pacific condominiums beside David Lam Park were some of the first glass condominiums to be built in Vancouver.

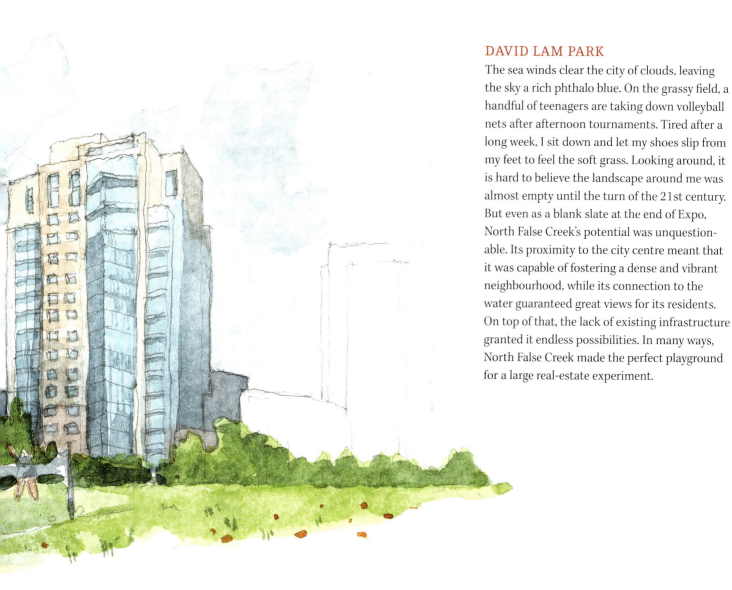

DAVID LAM PARK

The sea winds clear the city of clouds, leaving the sky a rich phthalo blue. On the grassy field, a handful of teenagers are taking down volleyball nets after afternoon tournaments. Tired after a long week, I sit down and let my shoes slip from my feet to feel the soft grass. Looking around, it is hard to believe the landscape around me was almost empty until the turn of the 21st century. But even as a blank slate at the end of Expo, North False Creek's potential was unquestionable. Its proximity to the city centre meant that it was capable of fostering a dense and vibrant neighbourhood, while its connection to the water guaranteed great views for its residents. On top of that, the lack of existing infrastructure granted it endless possibilities. In many ways, North False Creek made the perfect playground for a large real-estate experiment.

From Arthur Erikson's pencil sketch of soaring towers along Vancouver's waterfront in 1955 to the passing of the Strata Title Act in 1966 that enabled the horizontal subdivision of land, Vancouver has long embarked on a new urbanism that has embraced densification. But it was only with the availability of vast amounts of land along False Creek after Expo 86 that drastic changes were set into motion. At the time the land was put on sale, Hong Kong—a city deeply familiar with urban density—was about to be handed over to China after a century of British colonization. This was also when hitherto closed economies like China opened. Growing political uncertainty had pushed Hong Kongers overseas in search of investment and even immigration opportunities. It was not surprising then that the former Expo grounds ended up in the hands of Hong Kong developer Li Ka-shing under the Concord Pacific company.

LEFT 133. Many of the older condominiums used building technologies from climates that were quite different from coastal B.C., resulting in damage by rainwater infiltration. This was the infamous Leaky Condo Crisis.

RIGHT 134. Since the 1990s, many condominiums have been built on the Expo 86 fairground. Pacific Boulevard was the northern extent of the fairground and is now lined by residential towers.

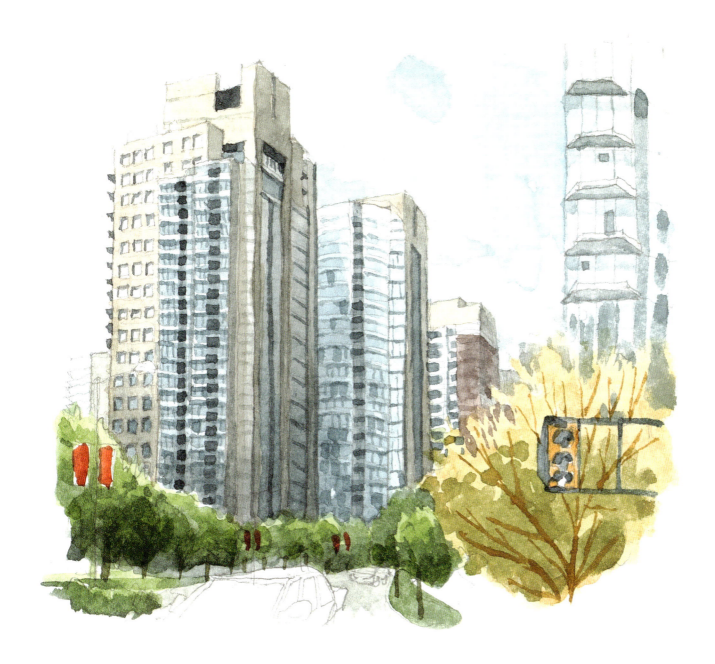

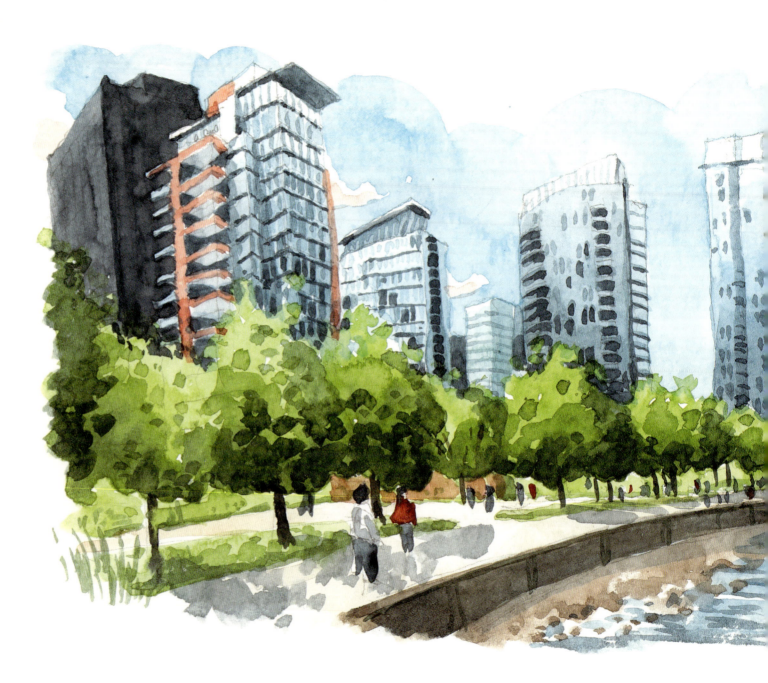

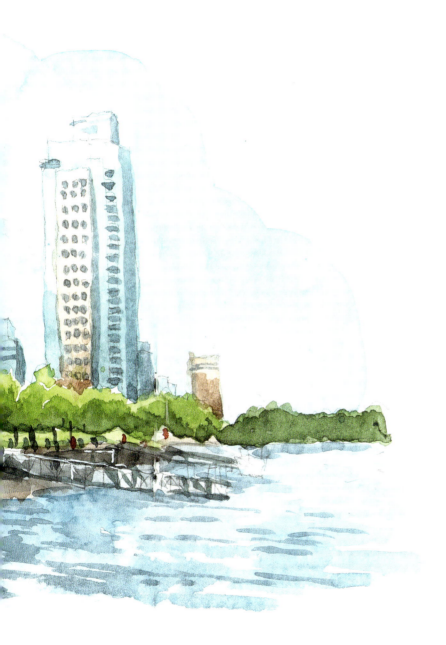

As my eyes rove over the area now, I see the towers of glass and concrete that flank either side of the park. Decades earlier, something called the Garden City Movement pushed for a sprawling city punctuated by park land, where humans lived in harmony with the environment. The introduction of condominiums, however, coupled with Vancouver's love for its famous views, flipped this 20th-century vision on its head. The Hong Kong developers transplanted their most familiar archetype—the residential tower—onto Vancouver. Yet here, the condominium has catalyzed a new form of urbanism, freeing much of the ground plane to allow more and larger parks and human-scaled townhouses, while the rest of the city dwells in the sky. It is this kind of neighbourhood that created Vancouverism and turned the city into a phenomenon recognized for its livability. Vancouverism has since spread across the globe to cities like Dallas and Abu Dhabi.[x]

135. Many condominiums have sprung up along the northern shoreline of Vancouver in Coal Harbour. Unlike the False Creek condominiums, these benefit from unobstructed views over the North Shore Mountains and the harbour.

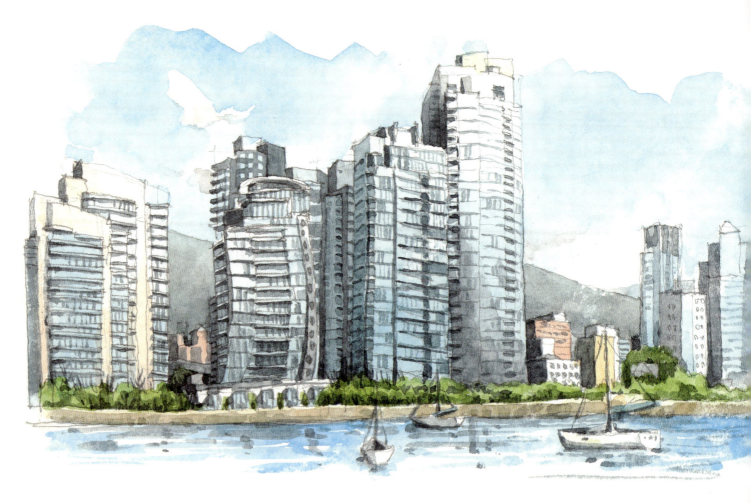

CHARLESON PARK

Vancouver appears tranquil today. Even the wind is dormant. The view looking out over False Creek is like a painting from a quiet museum. Before me is a scene I recognize from postcards: a forest of glass-clad condominiums with passing sailboats in the foreground and a chain of snow-capped mountains washed blue in the distance. While I have filled sketchbooks of drawings from this city, it is this view that I most associate with Vancouver. Ubiquity aside, this was the view printed on my deskpad in Hong Kong, the skyline I saw when I sat in front of my desk through my middle-school years. It never tires.

I once read an article criticizing Vancouver's "cookie-cutter" condominiums. It was suggested that they were banal. I agreed at first: from the tower's proportions to the colour of glass and concrete, almost all the condominiums along False Creek look similar. But as I paint the view in front of me, I uncover a unique quality inimitable in other modern cities. Rather than comparing Vancouver's skyline to a modern metropolis, perhaps it is more like an Italian hillside town. The novelty and uniqueness at play in the skyline of cities like Hong Kong may be absent, but the repetition here has achieved a cohesive and

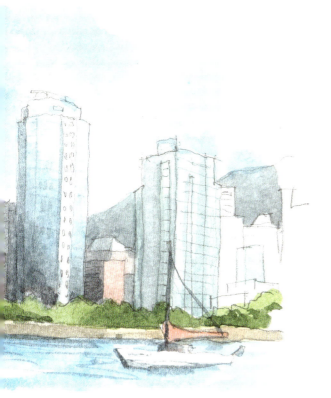
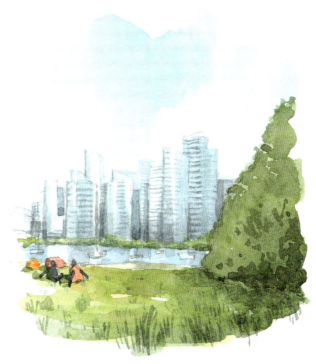

TOP LEFT
136. The view from Charleson Park is a scene often printed on postcards.

TOP RIGHT
137. While a large part of Charleson Park is a dog park, its large fields are also popular for sports and lounging.

BOTTOM
138. Many boats are scattered out over False Creek.

organized relationship, a stunning harmony between the city and its natural setting.

While an Italian hillside town is built with local stone to provide continuity between it and its environment, Vancouver's glass condominiums *reflect* the environment, the snow-capped mountains, the sea and the sky, giving an organic wholeness to the entire city scene. Glass—the material so frequently used around the world for its transparency—has found an entirely new meaning in this corner of the Pacific.

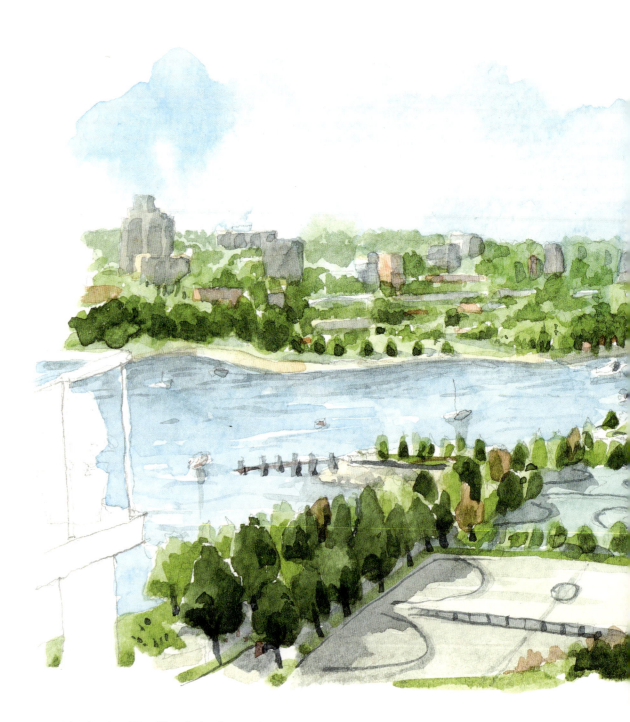

139. False Creek and David Lam Park in the morning.

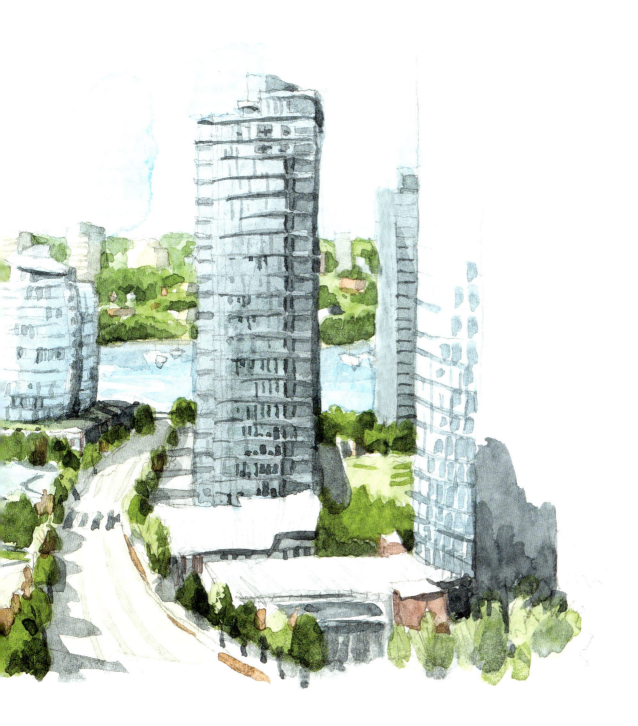

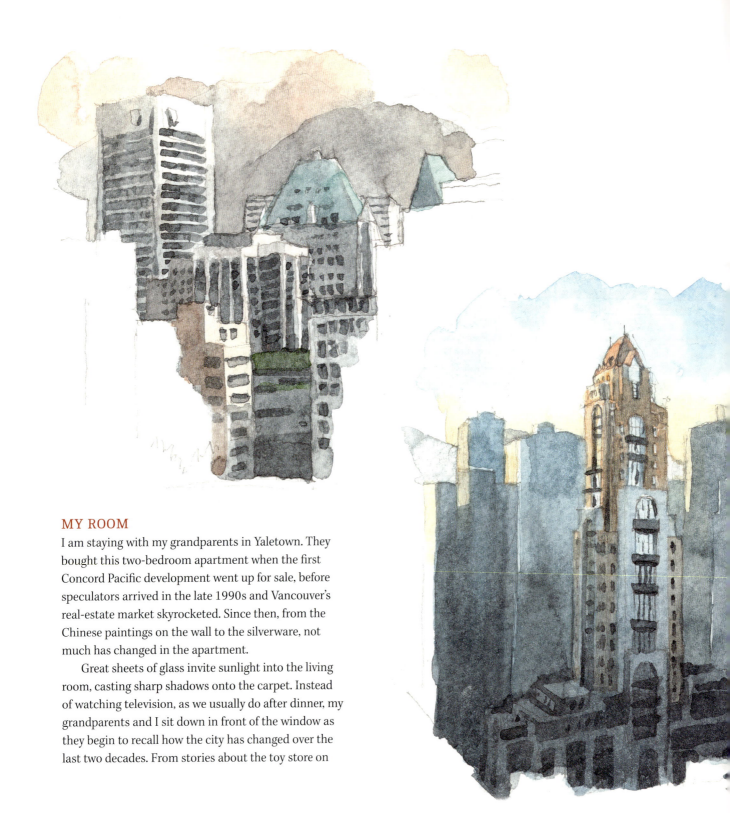

MY ROOM

I am staying with my grandparents in Yaletown. They bought this two-bedroom apartment when the first Concord Pacific development went up for sale, before speculators arrived in the late 1990s and Vancouver's real-estate market skyrocketed. Since then, from the Chinese paintings on the wall to the silverware, not much has changed in the apartment.

Great sheets of glass invite sunlight into the living room, casting sharp shadows onto the carpet. Instead of watching television, as we usually do after dinner, my grandparents and I sit down in front of the window as they begin to recall how the city has changed over the last two decades. From stories about the toy store on

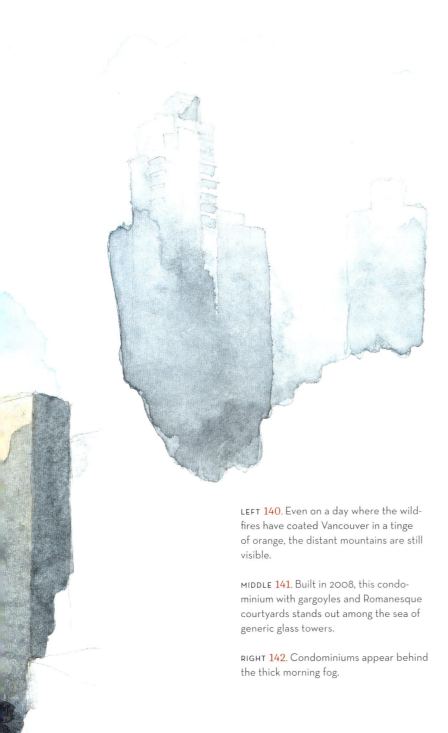

LEFT 140. Even on a day where the wildfires have coated Vancouver in a tinge of orange, the distant mountains are still visible.

MIDDLE 141. Built in 2008, this condominium with gargoyles and Romanesque courtyards stands out among the sea of generic glass towers.

RIGHT 142. Condominiums appear behind the thick morning fog.

Cambie they used to own to celebrations during the 2010 Winter Olympics, the city they have called home for the last two decades has transformed in front of their eyes. The extent of change is made most apparent when my grandmother systematically points out all the buildings that have been completed since my visit in 2000.

For the last few months, I have claimed the solarium as my bedroom, where floor-to-ceiling windows offer views out over the city. Although stunning views abound, my room faces north-west and receives little direct sunlight. Yet this only makes the views grander as the lack of sunlight hides all the nuances of the room, forcing my attention toward the spectacular vista outside. In much of Canada, the sun is a cardinal determinant in a building's orientation: south facing windows catch more sunlight, gifting inhabitants with much-welcomed warmth and light. But Vancouver's geography, with the mountains and Burrard Inlet to the north, prioritize great views over direct sunlight. I am not alone in favouring views over sunlight, a fact well known to realtors who splash keywords such as "panorama" and "skyline" all over construction-site billboards. In Vancouver, the condominium is not only the commoditization of land, but also of views.

Each morning from my bed I watch the mist rise and then dissipate to reveal the city against a backdrop of mountains. High up in the condominium, the streets below appear silent and the beautiful City of Vancouver looks no larger than an architectural model.

OUT OF FRAME

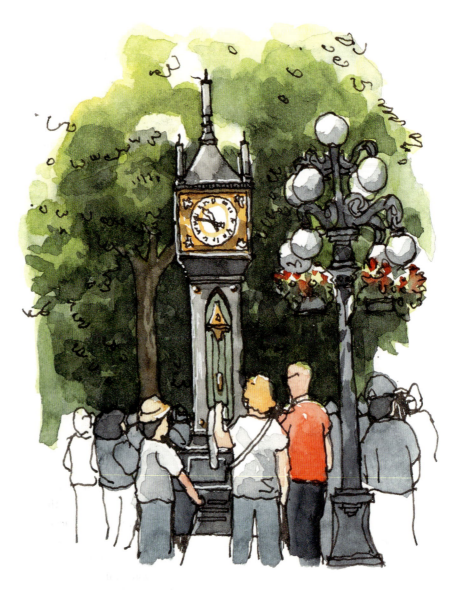

143. Wide-eyed tourists gather around the Steam Clock in anticipation of the whistling and shooting steam.

STEAM CLOCK

Every fifteen minutes in the heart of Gastown, a cluster of eager tourists gather to watch the Steam Clock chime the Westminster Quarters. Panes of glass on the clock reveal the inner workings of this "steampunk marvel" with its shifting brass nozzle signalling each passing second. But a closer look at the copper plaque at the base of the clock reveals its modernity—this is no Victorian artifact: it was built in 1977.

Before becoming a district filled with tourists, Gastown was a frequent haunt of the homeless, gangs, and sex workers. It was only in the 1970s, after its designation as a historic district, that Vancouver began to refurbish Gastown into what we see today. The Steam Clock—the most iconic tourist attraction in the district—was funded by local businesses as a new attraction—and also to cover a steam grate to stop the homeless from sleeping on it.

The disconnection between the appearance of the steam clock and its actual history hints at the hidden stories that underlie some of the pictures of Vancouver. Just as movie directors disguise the streets of Vancouver to imitate other cities, images do not always paint a complete picture of reality. My sketches capture moments in the city I am fond of, but there is far more to Vancouver than what meets the eye. While my drawings up until now have shown a postcard-ready Vancouver, rich in culture, there are far less savoury but no less important parts to the city that must be known. For the rest of this book, I must look beyond the parts of the city that have enamoured me all these years.

144. Simon Fraser University's Burnaby Campus is frequently used as a filming location. In the 2008 remake of *The Day the Earth Stood Still*, it starred as Fort Linwood Military Academy.

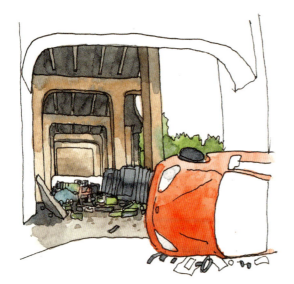

TOP 145. While the underside of Granville Bridge was under construction for Vancouver House, several scenes in *Deadpool Two*, were filmed here.

BOTTOM 146. Gate to the Northwest Passage, a sculpture in the form of a frame, can be spotted in Vanier Park. Installed to commemorate the arrival of Captain George Vancouver in Burrard Inlet, the sculpture also frames the skyline of Vancouver.

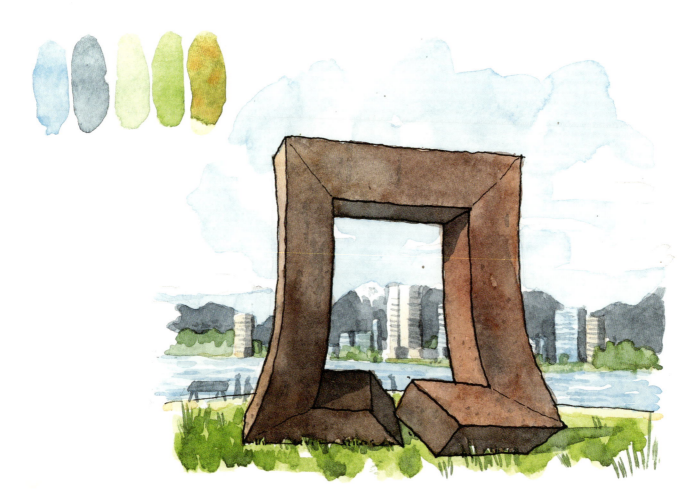

147. The Thunderbird House Post Totem Pole is perhaps the most striking and famous totem pole at Stanley Park. House Posts are traditionally used indoors to support the roof beam of a clan house.

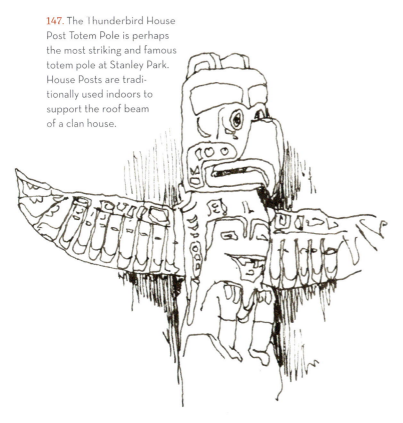

When I was four, my grandparents and I would take a break here during our bike rides along the Seawall. The iconography of the carvings was beyond my comprehension but the curious figures and bright colours made a deep impression on me and I collected souvenir models of them for several years. For some time thereafter, I believed this group of totem poles to be an accurate representation of how totem poles are used in First Nations cultures, when in reality, they are symbols of the city's troubled history with Indigenous peoples.

TOTEM POLES

One of the most ubiquitous images of Vancouver includes the totem poles in Stanley Park. From a distance, the group of totem poles blend into the backdrop of trees. The first indicator that I am nearing this destination are the rows of tour buses and horse-drawn carriages lining the sidewalk with crowds of tourists crossing the road. After negotiating the road myself, the noise from this crowd dissipates. In front of me, nine monuments tower over a group of tourists, shining bright in the afternoon sun.

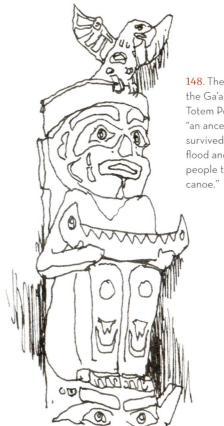

148. The top of the Ga'akstalas Totem Pole depicts "an ancestor who survived the great flood and gave the people the first canoe."

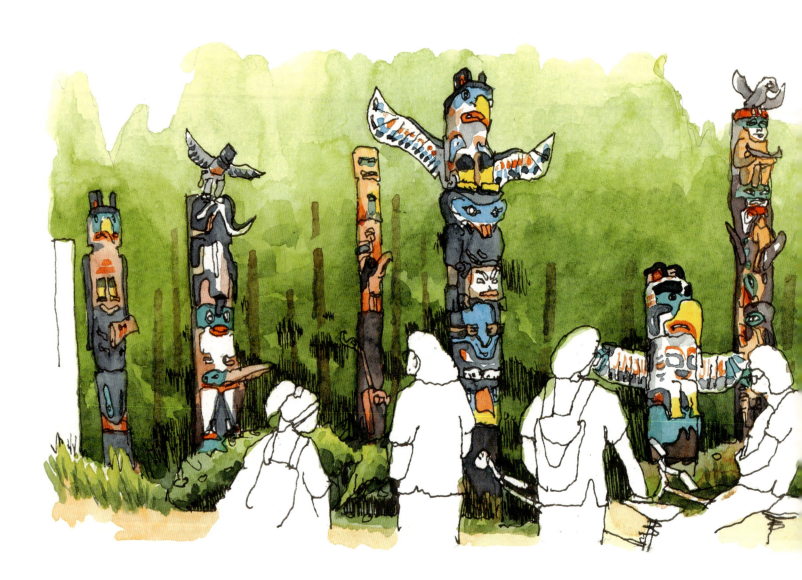

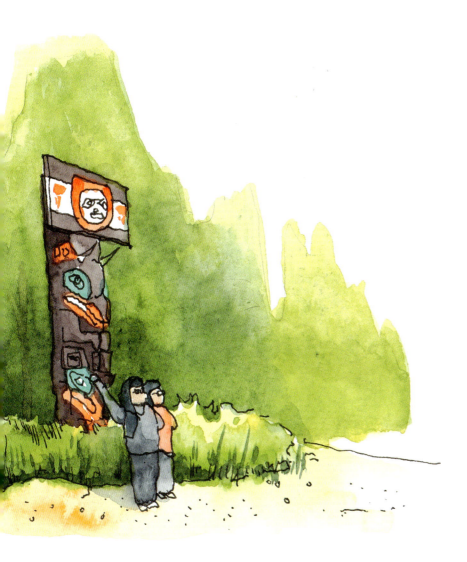

To understand the undercurrent that brought about this group of totem poles is to understand what used to stand in this very spot. While local First Nations were unceremoniously evicted upon establishment of Stanley Park, Europeans nevertheless wanted to "ensure the retention of some of the relics." Rather than preserve the abandoned village in the park, they wanted to create a new village with parts made out of more exotic materials. In their plan, they replaced wood with animal skin and just like that, a fantastical First Nations village was drawn up. They were interested not in the reality but in an aestheticized reinterpretation of local First Nations culture.

The painfully cheerful group of totem poles was the compromise when funding fell short for the construction of an entire village. The oldest pole dates back to the 1880s while the latest one was carved in 2009 by Squamish artist Robert Yelton. Examined individually, each pole tells a different story about the people who once lived here. But nowhere in a traditional First Nations village would so many totem poles be displayed so closely together. Furthermore, the poles came primarily from Haida Gwaii, Rivers Inlet, and Alert Bay–places far from Stanley Park. By bundling together poles from diverse locations and groups, the collection might leave the viewer wondering if this is anything more than visual spectacle.

149. The group of totem poles rises above the meadow at Brockton Point.

SHAUGHNESSY HEIGHTS

While Vancouver has become a highly desirable city to live in, earning itself titles such as "the most livable city in North America," this has accordingly created a very high demand for housing. The influx of newcomers and the scarcity of land has bloated the real-estate market and transformed Vancouver into a city of millionaires—the average household net worth is more than one million dollars, the highest in Canada.

Vancouver's wealth is on display almost everywhere you go. In the fashionable districts there's a cycle of shopping and partying. Prada-wearing teenagers zoom by in brightly-coloured supercars—birthday gifts from their parents. Even as a self-identified upper-middle class man, I often find myself feeling a little down at the heel in comparison. Fact is, these are not millionaires: many are multi-millionaires living opulent lifestyles. The problem is, not only is Vancouver home to some of the richest people in the country, it is also home to some of Canada's poorest families.

150. A large house in Shaughnessy Heights, one of the most expensive neighbourhoods in Canada.

HASTINGS AND MAIN

The concept of Vancouverism seems to solidify the city's identity, claiming this style of urban planning as the definitive ideal for North America's most livable city. Yet there's another side to this city, a place that seems ages away from the vibrant tourist districts of Gastown and Chinatown. And that other side is no better represented than at the intersection of Hastings and Main: a place called the Downtown East Side, a district known for drug abuse and homelessness. My grandparents have warned me repeatedly not to walk through the area, and many other locals will tell you the same. But as for me, someone committed to sketching this town, a trip along Hastings is necessary. I have to see "Vancouver's worst neighbourhood" for myself.

In the incessant snow, a sea of loiterers mill beside the dilapidated historic brick façades of East Hastings. Others sit along the edge of the sidewalk, beside torn tents and rusted shopping carts, their breath visible in the chill air. Above, enormous payday loan signs flash bright colours against the ominous steel-grey sky.

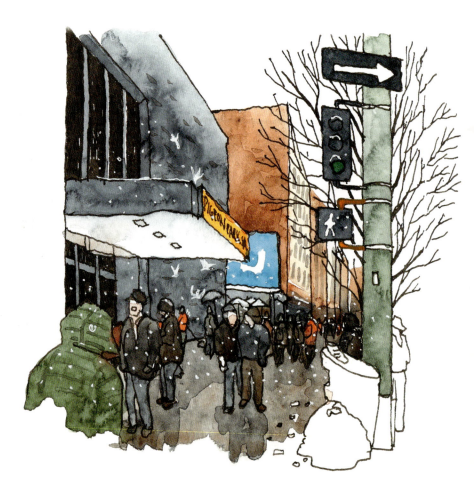

LEFT 151. In the 1950s, East Hastings was Vancouver's main entertainment district. A lot has changed and today, a sea of loiterers gathers outside the entrance to a flea market.

MIDDLE 152. Save-On Meats started as a butcher shop and now includes a diner. Its neon pig sign has been in place since the 1950s.

RIGHT 153. An enormous payday loan sign flashes its bright colours above the torn tents of East Hastings Street.

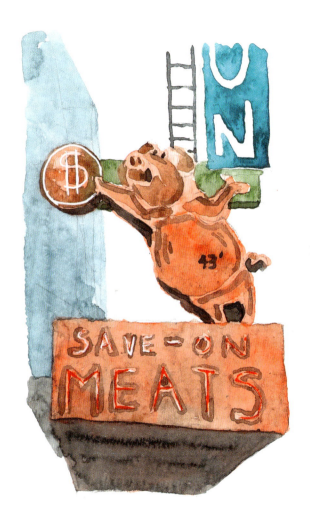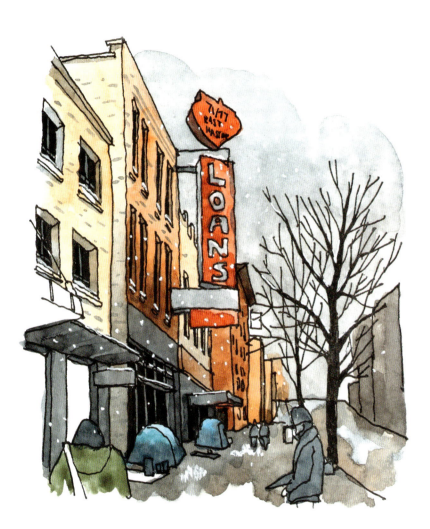

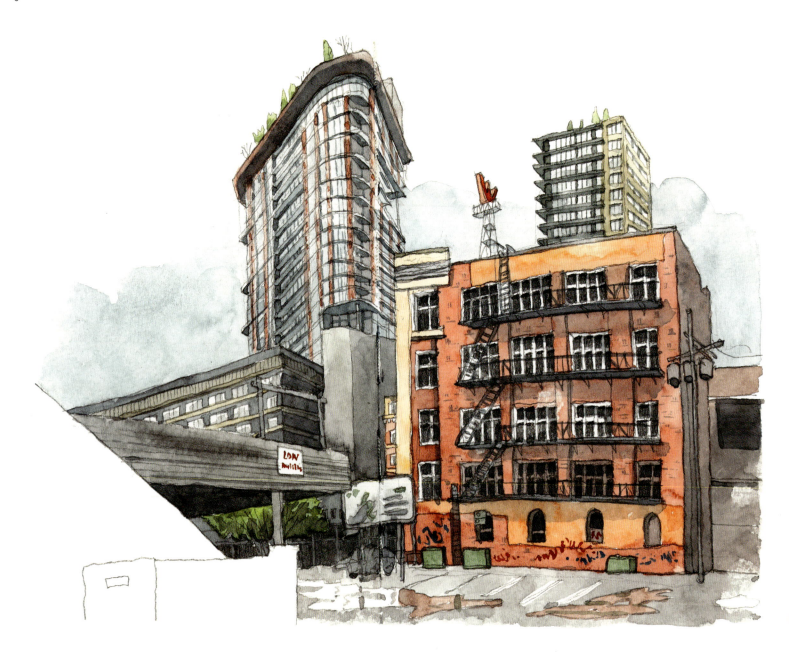

154. Woodward's Development spotted from an empty parking lot on West Pender Street.

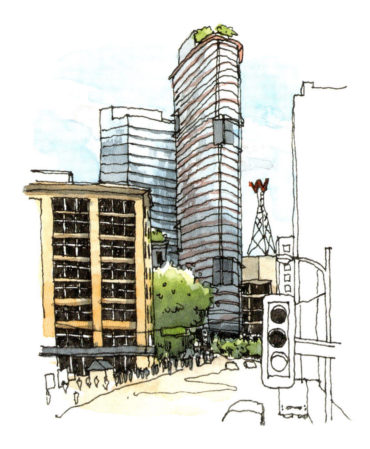

It is a grim place, and it is as much a part of this city as any other.

There have been many attempts at rejuvenating the forgotten neighbourhood, but none have been as notable as the Woodward's Development at the intersection of Hastings and Abbott streets. Completed in 2009, the development replaced the old Woodward's factory to offer market and non-market rate housing along with a plethora of community and retail spaces. The crown of the development is—of course—a condominium, rising high above the neighbourhood as a proud addition to the skyline.

While many people have praised Woodward's Development as a prime example of community rejuvenation, some have condemned its weathering-steel clad façade for aestheticizing the industrial history of the neighbourhood, thus further gentrifying it. Just half a century ago, Vancouver transformed the industrious Granville Island into artistry. Today, a similar transformation made to the Downtown East Side, under the guise of enhancing the city's appearance, will inextricably link this area to the real estate market and unwittingly, make the city even more unaffordable.

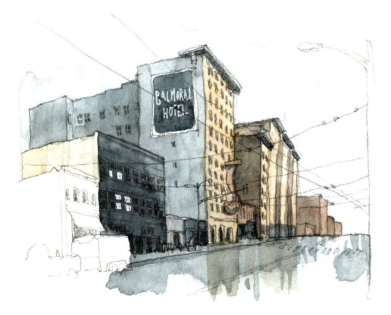

TOP 155. Seen from Granville Street, the glass towers of the Woodward's Development punches through the historic skyline of Gastown.

BOTTOM 156. Built during the economic boom of the 1910s, the Balmoral Hotel has since fallen into disrepair. In 2018, the City of Vancouver deemed the shabby building uninhabitable due to safety concerns and expropriated ownership of the hotel.

MORE THAN A CITY OF GLASS

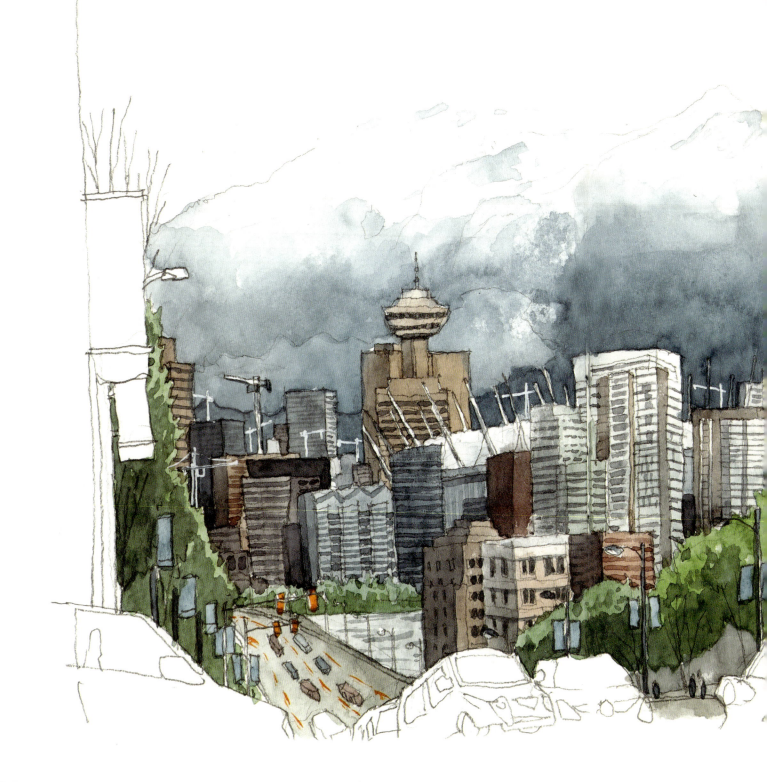

Ten thousand years ago, the glaciers that covered the entire continent receded north and left behind minerals on a stretch of land between the Rocky Mountains and the ocean. Over several millennia, life took hold and the once-barren landscape became home to a rich and diverse ecosystem. The first people to live on this land, the First Nations, saw themselves as an integral part of nature, subsisting on the region's plentiful resources until Europeans arrived and began employing those same resources as fuel for hungry industries. As resources were depleted and consumed, this corner of the planet became wealthy and the City of Vancouver was born.

After building some of the British Empire's tallest buildings, the Great Depression arrived and the region's natural beauty assumed a new relish. Resource was turning into revelry. By the 1960s, every license plate in the province was embossed with the words "Beautiful British Columbia." From the construction of the Seawall to the revival of Granville Island, Vancouver's picturesque identity slowly took form. By the 1980s, the success of Expo 86 put Vancouver on the global stage and another wave of immigration ensued. Flooded with foreign investments, condominiums began to populate Vancouver's skyline and Vancouverism—a mode of urbanism stressing livability-was born.

While Vancouver's concern for nature and beauty has created the city we see today and is making it one of the most livable cities in the world, change is again on the horizon. Vancouver has already seen dramatic transformations over the last decades, and as Asia continues to expand as an economic power, Vancouver's position between it and the eastern coast of North America will become even more advantageous. It seems wealth will increasingly flow through the city's economy and this wealth will certainly affect Vancouver's livability.

157. Downtown Vancouver from Cambie Street. (Notice the cranes at work.)

In fact, Vancouver was dethroned as Canada's most livable city by Calgary in 2018. Although many factors led to the lowered livability ranking, unaffordable housing is cited as a primary concern. With rising housing prices came speculation, where large investments bring prices to unattainable heights and de-couple the real estate market with those who actually live in the city. Thousands of empty homes in Vancouver testify to the amount of real estate speculation going on, disheartening younger generations and even those with high-paying professions.

The City of Vancouver has implemented different policies to control the real estate market, including a Vacancy Tax (Empty Homes Tax) in 2017. However, housing prices continue to be a hot topic and with all the glass condominiums that have come to populate much of the city's skyline, it is clear that the local economy continues to rely greatly on real estate. It is no surprise that Douglas Coupland called Vancouver a "City of Glass"—real estate is king in Vancouver.

That said, Vancouver has much much more to offer than investment opportunities. Throughout the book, I have attempted to tell some of the stories behind Vancouver's current pictorial identity through scenes that inspired me to draw. Although I began sketching Vancouver only casually, I was quickly overwhelmed by the extraordinary wealth of history and culture that underlies this contemporary picturesque city. Just as I have learned a lot from Vancouver, I hope that this book has offered you a glimpse of the richness of Vancouver's natural and cultural beauty.

While Vancouverism has brought the city to where it is today, I would like to believe that it is not the city's final form of urbanism. As the city continues to develop, its urbanism will evolve to tackle the more salient challenges such as housing affordability, reconciliation with First Nations, and a widening social divide. At the same time, Vancouver's pictorial identity, just as it has over the last three thousand years, will inevitably evolve and offer new and even more beautiful opportunities.

TOP 158. Although Vancouver is no longer an industrial city, B.C. continues to be a large exporter of timber. Completed in 2016, UBC's Brock Commons student residence—the world's tallest wood building—hints at the potential of tall wood structures.

RIGHT 159. Rather than replicating the glass towers that already dominate downtown, Vancouver House is one of many new developments that introduce new and curious forms to the city's skyline.

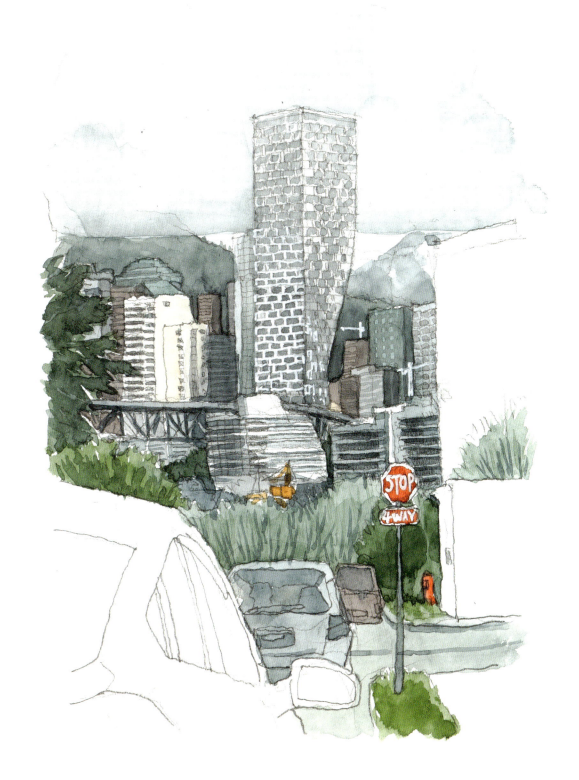

NOTES

i. David Oppenheimer, "Speech at Opening of Stanley Park" (speech, Opening of Stanley Park, Vancouver, BC, 1888).

ii. Rhianna Schmunk, "Siwash Rock needs its 'derogatory' name changed, park board commissioner says," CBC News, September 29, 2017, https://www.cbc.ca/news/canada/british-columbia/siwash-rock-renaming-1.4312151.

iii. George Vancouver, A Voyage of Discovery to the North Pacific Ocean and Round the World, Volume 1 (London: G. G. and J. Robinson, 1798), p. 254.

iv. George Vancouver, The Voyage of George Vancouver, 1791-1795, vol. II, ed. W. Kaye Lamb (Cambridge: Cambridge University Press, 1984), p. 259.

v. Major James Skitt Matthews, Early Vancouver, Volume 5 (Vancouver, BC: City of Vancouver Archives, 2011), 58.

vi. Maurice Jassak, "Chinatown, Vancouver, British Columbia: Sam Kee Building–1913," last modified July 10, 2016, http://www.seechinatown.com/thin/thin.htm.

vii. Director of Planning in consultation with Director of Housing Policy, 'Historic Area Height Review: Conclusion and Recommendations', Policy Report Development and Building, RR-2(a), January 4, 2010, https://council.vancouver.ca/20100119/documents/rr2a.pdf, Imperial Trust Company, ca. 1908.

viii. Sean Kheraj, Inventing Stanley Park: An Environmental History (Vancouver, BC: UBC Press, 2013).

ix. Ebenezer Howard, "The Three Magnets," Garden Cities of Tomorrow (London: Swan Sonnenschein & Co., 1902).

x. Larry Beasley, "Planning the Global City: Vancouver, Abu Dhabi and the World," (Lecture, University of Toronto Urban Lecture Series, Toronto, Ont., November 16, 2011).

ACKNOWLEDGEMENTS

This book is very much a collective effort and a great deal of thanks is owed to the group of friends who helped me along the way. Eric Oh for discussing the book's thesis with me on a tiny sailboat in Rotterdam. Andrew Keung for assisting on some of the book's research and more importantly, for keeping me on track when life became distracting. Joy Carter for the encouragement and support. Monica Patel for happily editing various drafts of the manuscript. Tristan Sito for exploring Vancouver with me. Sharon Fitzhenry, Richard Dionne and Andrew Bagatella from Whitecap Books, it was an absolute pleasure working with you on this book.

 My grandparents in Vancouver, thank you for moving here all those years ago and bringing me back here. The stories of love and of war you told every night after dinner have been inspirations for this book.

 I owe thanks most of all to my parents, Ben and Judy. Even in the most challenging of times, you have only shown me boundless grace and love. Dad, thank you for encouraging me to start sketching on-location, for teaching me the importance of hard work, and for showing me how to seize opportunities. Mom, wherever you are, thank you for opening my eyes up to the rare moments of Beauty in this world.